Testin

"This book is essential reading for any woman in business or indeed anyone who is passionate about supporting women at work. Shona provides practical strategies and tools that you can apply immediately in your career to enhance your success. I've worked with Shona for almost a decade supporting Women in Transport. She is an exceptional high-performance coach and inspirational speaker and I highly recommend her programs and this book."
Sonya Byers, CEO, Women in Transport

"This book is a must read for anyone who wants to maximise their career opportunities and potential. Shona's passion for empowering women emanates from every chapter. Her book provides practical tips and strategies on increasing your confidence, overcoming fear and self-doubt, raising your profile, building your networks - and much more. This is coupled with delightful anecdotes from Shona's personal life and her coaching programs - guaranteed to give you 'aha' moments, make you smile, and (if you're like me) even impact you emotionally (in a good way!). Having attended a number of Shona's events and being fortunate enough to attend her 'Career Acceleration Program', I highly recommend this book which contains some of her most inspirational and insightful material".
Natalie Mascarenhas, Senior Consultant, Baker McKenzie

i

"Shona has been my coach in different capacities over the last ten years. This book represents what kind of coach she is: engaging and inspirational, and at the same time she has a deep understanding of the blockers and challenges women in business face. She translates solutions into practical advice that can be implemented straight away. Shona has coached me to unblock my fears and insecurities and has helped me find my true authenticity and strengths."

Stefanie Komar,
Global Communications Manager, Shell

"This book is a fantastic read. It's got so many helpful tips and tricks on how to create a more successful and fulfilling career, no matter what industry you work in. From overcoming self-doubt, to tackling imposter syndrome – there's something for everyone! Shona has a unique gift – the way she can break down complex concepts and explain them in a way that's easy to understand with plenty of real-life examples, including her own experiences. Really enjoyed her personal approach to this book. Highly recommend!"

Gemma Graffin, School Psychologist

"This book is a powerful mix of inspiration and practical takeaway points to help people achieve their career goals. I highly recommend this book to anyone who wants to up their game and go for what they truly want. Shona will help you get there!"

Claire Klincewicz,
Marketing Manager, IBM

"Shona's Career Acceleration Program is by far the best development program I have ever attended. Every session brought new insights, learnings and practical tips to overcome issues. I couldn't recommend this any higher. It is awesome!"

Marie Conroy, Communications Manager

"Having been recommended Shona by one of our clients, we engaged her to develop a Career Acceleration Program specifically designed for Lockton Women. We had outstanding attendance and amazing feedback at each of the informative and interactive sessions she delivered. I highly recommend Shona to any organisation who wants to support their female staff and clients!"

Carla Moffett, Partner, Lockton

"Shona kicked off our Women's Leadership Summit and she was the perfect person to do so. Hosting conferences in the virtual environment is a difficult challenge and Shona made it look effortless. She provided an engaging session that was full of energy, not to mention it was the middle of the night for her as she's based in Australia and we're in the US. Shona provided action items and tips to over 200 of our female attorneys and we received a lot of positive feedback from her session. I highly recommend Shona for your speaking engagement and look forward to working with her on future endeavours."

**Jullia Carretta, Senior Manager –
Professional Development & Diversity,
Wilson Sonsini Goodrich & Rosati**

"It was a pleasure to work with Shona and I got so much out of our coaching sessions! Shona is a well of information in relation to practical ways to develop your potential and play to your strengths. She has given me many helpful tools to grow my profile and leverage opportunities. I've confidently recommended her to my friends and received so much great feedback. Thanks, Shona!"

Belinda Wong, Senior Associate, Corrs

"Shona is a highly engaging, informative and authentic speaker. The extremely positive feedback we receive from our people speaks as much to her practical and actionable advice, as to her ability to inspire and connect with an audience – you can always feel the energy whether in person or virtual!"

Ishtar Barranco, Digital advisor and Senior Geologist, Chevron

Secrets to Success

The Psychology of Successful Women

THE ULTIMATE GUIDE TO ACCELERATE YOUR CAREER, BOOST YOUR PERFORMANCE AND THRIVE

SHONA ROWAN

Cover design: Nicole Halliday
Layout and typesetting: Ultimate World Publishing
Editor: Emily Riches

Ultimate World Publishing
Diamond Creek,
Victoria Australia 3089

Dedication

My heartfelt thanks to everyone who has supported
me throughout my life and on my business journey.
To my family, friends and husband Paul – thank you
for always believing in me. To my amazing clients,
coaches, mentors and podcast guests who never
cease to inspire me.

Finally, to you the reader. I am so glad our paths
have crossed – this book is for you.

Contents

About the Author

Shona Rowan is a performance and mindset consultant, inspirational speaker and high-performance coach. She is also the founder of *The Psychology of Successful Women* – Career Acceleration Program and Podcast.

Shona has over 15 years of international experience working with Fortune 500 companies, leading professional service firms, entrepreneurs, business owners and career-minded individuals to maximise their performance and accelerate success.

Shona helps organisations build inclusive, high-performing teams; grow leadership and management capability; and support, develop and retain their female talent. Through her inspirational events and

global programs, Shona has helped thousands of women accelerate their careers, overcome imposter syndrome and self-doubt, boost their performance and maximise their success – according to what 'success' truly means to them.

Shona's unique approach combines extensive study, qualifications and practical experience in Psychology, Hypnotherapy, Neuro-Linguistic Programming and Peak Performance to design and deliver programs that get results.

Prior to forming her own coaching, speaking and consulting business, Shona was ranked sixth in the world as a Ballroom and Latin American 10-Dancer and has represented Australia in 12 different countries. Having grown up in the world of competitive sport, Shona has lived and studied peak performance and success psychology for more than 25 years and is deeply passionate about helping people unlock their unique potential, fast track their success and thrive in their chosen field.

Find out more about Shona's work or connect with her via the following platforms:

- www.shonarowan.com
- www.psychologyofsuccessfulwomen.com
- www.linkedin.com/in/shonarowan/
- www.instagram.com/shonascouch

About the Book

What made you pick up this book? Perhaps you would like to:

- Accelerate your career and maximise your success?
- Overcome self-doubt, imposter syndrome or people pleasing?
- Boost your impact, influence and profile?
- Discover mindsets, behaviours and strategies to help your career soar?

Whatever the reason, I'm so glad you're here!

This book draws on over 15 years of experience as a high-performance coach to equip you with a practical, step-by-step guide to accelerate your career and maximise your success, according to what success truly means to you. It unpacks key themes, topics and challenges that have come up with my female clients during workshops, inspirational events and private coaching sessions over almost two decades. It also includes essential tools and actionable advice from the *Career Acceleration Program* and identifies specific mindsets and behaviours of high-achieving women.

The Psychology of Successful Women first began life as an inspirational 90-minute workshop and over time, as its popularity has grown, it has expanded into two signature programs, a keynote presentation and *The Psychology of Successful Women* Podcast.

This book takes a holistic approach to career and business success by combining the internal (mindset and psychology) with the external (behavioural and practical) to amplify your results.

It is my heartfelt intention that this book will help anyone who is drawn to read it to create a successful and fulfilling career on their own terms.

How to get the most from this book

This highly practical book has been designed to share concepts that are easy to pick up, personalise and implement. Each chapter includes reflective questions, exercises and coaching activities to help you take action and remove fears and doubts that might be holding you back – often subconsciously. It also combines a range of tools and techniques from the fields of Psychology, Peak Performance, Neuro-Linguistic Programming, Hypnotherapy and Coaching to help you succeed and thrive.

Every person I work with is different and has their own unique strengths, development areas, values and goals. As such, I encourage you to reflect on your own mindset, behaviour and performance as we go

through the book and to apply the strategies within each chapter that resonate the most with you.

To support you on our journey together, I have created a bunch of additional resources that will guide you throughout this book. Go to: www.shonarowan.com/pswbonuses to download the book resources. I also created a PSW Spotify playlist for those of you who love inspirational music.

As you read this book, I want you to picture me as your personal coach – supporting you, challenging you and cheering you on. I am so pleased you are here. Let's get started!

INTRODUCTION

Set Yourself Up for Success

"Success isn't about how your life looks to others. It's about how it feels to you."

— Michelle Obama

As far back as I can remember, I have always been fascinated by people and what makes us tick, so when I enrolled at university, I knew psychology was the right choice for me. Whilst completing my degree, I began reading as many books as I could on peak performance, professional development, mindset and sport psychology. Within these texts were many inspirational stories of people who had overcome huge personal or professional challenges and beaten the odds to achieve world class performance and deep fulfilment... I was hooked. It was like a lightbulb came on for me and I knew deep down inside that I wanted

to help people achieve their goals and boost their success and happiness.

I have now been working as an inspirational speaker and high-performance coach since 2006, and I've had the huge pleasure of helping people all over the world accelerate their careers and maximise their results.

When it comes to success and high-performance in any industry, it typically doesn't happen by chance. There are certain mindsets, behaviours, tools and strategies we can use to stack the odds in our favour. Similarly, there are common factors that can hold us back – consciously or subconsciously – from achieving the things we deeply desire. The pages that follow will cover both sides of this 'success equation', but first, this chapter is all about setting yourself up for success and includes three key foundational principles of high-performance.

Foundation 1: Clarify your vision of success

What does success mean to you?

Success means different things to different people, so the first step is for you to clarify what success looks and feels like for you right now in your career or business. There is no one-size-fits-all definition of success, and all my clients have their own definition based on their personal and professional values.

Now, I am not talking about specific career goals or business outcomes just yet. For now, I just want you to think about what success means to you at a higher level.

Coaching questions:

- How do you define success?
- What does it look like to have a successful and fulfilling career or business right now?
- What is your vision?
- What does it feel like to thrive in your professional life?

"Success is liking yourself, liking what you do, and liking how you do it."

— Maya Angelou

Whilst success means different things to different people, how we define success is likely to change as we move through different stages of our careers and lives too. This has definitely been the case for many of my clients, and tracks with my own personal experience.

Back in 2006 when I had just moved to London, I had no commitments and I was a complete workaholic! I worked extremely long hours, travelled all the time for keynote events and workshops, and said yes to every opportunity and invitation to go networking. I was focused on establishing myself as an inspirational speaker, consultant and performance coach, and

building my brand and client base. I never took a break, drank buckets of coffee and was terrible at any form of self-care.

Nowadays, like many of my clients, I value a more holistic and sustainable idea of success that not only looks good on the outside, but also feels good on the inside. I'm at a different stage in my career and business, and the world of work has changed since COVID-19 too. As such, I have made changes to my business and the way I work to support this. For example, I now deliver a lot of my events and programs online via video conference. This provides greater flexibility for my clients as they can attend from anywhere in the world, from their home or place of work, and location and travel are no longer a factor. I also prioritise my health and wellbeing much more these days.

It's about creating success on our terms and living in alignment with our core values.

When we get really clear on what success means to us at a deeply personal level, it's much easier to make that vision a reality and to avoid the comparison trap! It will also ensure you don't end up chasing an idea of success that doesn't align with your personal and professional values, or one that no longer works for you. As such, you will avoid wasted time and energy heading in the wrong direction.

Foundation 2: The power of written goals

"Setting goals is the first step in turning the invisible into the visible."

— Tony Robbins

Once you have given yourself the time and space to connect with your unique definition of success, it's important to drill down further into some of your specific career or business goals. Goal setting is key to success and something I first learned to do in my early teenage years when I started competing internationally as a Ballroom and Latin American dancer. Our coaches taught us that goal setting is a fundamental key to success and was something that all the top dancers around the globe were doing. I started to read books on peak-performance and found that the top performers in any field – from business to sport – all talk about using goal setting to maximise their results.

What do you want to achieve in your career or business? What are some of your specific goals?

To help you get started, here is a list of some of the common things that come up with my clients:

- Boosting their personal or business performance
- Overcoming self-doubt, imposter syndrome or perfectionism
- Communicating with impact, influence and credibility

- Strengthening their brand and profile, online or offline
- Making a career leap, or taking back control of their career path
- Achieving a specific promotion
- Building strong relationships and expanding their professional network
- Boosting their visibility

The forthcoming chapters cover lots of practical strategies to help you achieve your goals and boost your success, but for now, just take a moment and ask yourself: **"What do I really want to be…. do… and have in my career?"** Think about some of your short and long-term goals that link back to your vision of success – the more specific you can be the better.

In terms of all the tools and techniques I help my clients with, I have to say that written goal setting is one of the fastest ways to raise your performance and improve your results. There is huge power in clarifying your goals and committing them to paper. Our chances of success increase when we move from a vague wish or dream to actually writing them down, and that's because writing things down helps to wire them deep into our subconscious mind.

Just how powerful is written goal setting? A study on goal setting at the Dominican University in California showed you are 42% more likely to achieve your goals if you write them down. Written goals are proven to increase your focus, strengthen motivation and help you come up with a plan of attack to make your dreams

a reality. They help you engage the right resources and support, and enable you to track and measure your progress. All the high-achievers I know (regardless of the industry they work in) are powerful goal setters.

I was reading through one of my old journals the other day, and I could not believe how many things had come to fruition. Things about my business, the Career Acceleration Program and writing this very book. So right now, I strongly encourage you to write some of your goals down so you can revisit them in the future. I dare you to aim high and dream big! Once you see how powerful it is, you will want to use goal setting time and time again to achieve new heights for your career or business.

"Decide what it is you want, write it down, review it constantly, and each day do something that moves you toward those goals."

— Jack Canfield

Foundation 3: Success starts within – the power of your mind

"You become what you believe."

— Oprah Winfrey

I have always been intrigued by the power of our minds, so after studying psychology, I also became certified in hypnotherapy and neuro-linguistic programming. When I started working as a performance coach, I became especially intrigued by how my client's thoughts, beliefs and expectations positively or negatively impacted their professional achievements, career success and business outcomes. I also started noticing some common differences in mindset between many of my male and female clients – some of which I will cover in this book.

Did you know we have approximately 60,000 thoughts a day?

Our thoughts impact everything from our confidence, our motivation, our resilience, our stress levels, our happiness, our behaviour and our overall performance.

Let's face it: we can have all the knowledge and skills in the world, but when our mindset is in the wrong place, we never perform to the best of our abilities.

"When you truly study top performers in any field, what sets them apart is not a physical skill, it's how they control their minds."

— Stan Beecham

I know from personal experience and from working with thousands of people over the past 15 years, that mindset is frequently one of the biggest blocks to success. Often, it's our fears and doubts or our limiting thoughts and beliefs that hold us back from the success we desire and deserve – consciously or subconsciously. Things like a lack of self-belief, a fear of being judged or criticised, imposter syndrome, negative comparisons, perfectionism, or a deep-seated fear of failure.

So, when it comes to achieving your goals or boosting your success, it's not enough to come up with a plan that only looks at what you need to 'do' at a behavioural level. It's important to think about both mindset *and* behaviour to ensure they are aligned with the results you want to achieve.

Importantly – our mindset impacts our feelings, our behaviour and our results.

KEY TAKEAWAYS:

1. Get crystal clear on what success looks and feels like to you in your career or business right now.

2. Identify some of your key goals and write them down.

3. We must consider both our mindset and our behaviour if we want to maximise our chances of achieving our goals.

Now that you have clarified your vision of success and pondered some of your key goals – let's get stuck into some of the key mindsets, behaviours, tools and strategies that can fast track your success and accelerate your career.

Strengthening Confidence and Self-Belief

"Believing in yourself is the first secret to success."

– Buddha

What practical tools and techniques can we use to build self-confidence? Why do so many smart, talented and hardworking people struggle with self-belief? Are there gender differences in confidence?

When it comes to achieving your goals and accelerating your career, self-confidence is a superpower. It helps people gain respect and recognition in the workplace, and it impacts our thoughts, our beliefs, and our behaviour. Not only does confidence impact our success, it also impacts our well-being and happiness. Studies have shown that people with higher levels

of self-confidence tend to experience increased job satisfaction, higher income and lower levels of stress and burnout.

Of course, when I say self-confidence, I am not talking about arrogance or delusions of grandeur, but rather a genuine belief in one's skills, knowledge and ability to succeed.

What is this elusive thing we call self-confidence?

The American Psychological Association (APA) defines self-confidence as:

> *An individual's trust in their own abilities, capacities and judgements, or the belief that they are capable of successfully meeting the demands of a task.*

Confidence has nothing to do with being an extrovert, and both introverts and extroverts can have high or low levels of self-confidence. Interestingly, the word confidence comes from the Latin word *fidere* which means "to trust." So ultimately, confidence is all about having trust in oneself.

Self-confidence is multifaceted. Many things can impact our confidence, including our upbringing, education, personality, life experiences and what we attribute our successes and 'failures' to. In addition, the people we associate with personally and professionally, and our workplace culture and environment, can also affect our confidence.

Furthermore, you might feel confident in some situations but not others. For example, you could feel highly confident managing your team, but not when speaking in public. Or you may feel confident networking in person, but not online – for example, posting articles or videos on LinkedIn. When and where do you feel most confident?

"Nothing can be done without hope and confidence."

— Helen Keller

Self-belief is a common topic that arises in my programs and coaching with women, and it's something I've had to work on personally throughout my career. In fact, my original inspiration for *The Psychology of Successful Women* program came from noticing just how many intelligent and highly skilled women were experiencing self-doubt and imposter syndrome regardless of their role, level or industry. While every person is unique, research does point to potential gender differences in self-confidence. For example, some studies indicate that women typically underestimate their intelligence and abilities, and struggle with self-doubt more than men.

Although self-confidence is a powerful key to success, many things can happen in life and at work that shake our self-belief. As your career grows or you step into a bigger role, move to a new company or country, or return from a period of leave, you may find yourself

needing a confidence boost. The good news is we can take steps to overcome self-doubt and build authentic confidence!

So, how can we strengthen our confidence? What practical tools and techniques can we use to boost our self-belief?

Strategy 1: Develop empowering and supportive self-talk

> *"Talk to yourself like you would talk to someone you love."*
>
> — Brené Brown

Self-confidence is powerfully connected to our mindset: our thoughts, beliefs and what we focus on. If we want to strengthen our confidence, a great place to start is by developing empowering and supportive self-talk.

Start to notice your internal dialogue. How do you speak to yourself on a daily basis? Is it mostly positive or negative? Supportive or critical?

Become especially curious about how you speak to yourself when you make a mistake or when things don't go to plan. For example, do you reassure yourself, or do you beat yourself up? Are you kind to yourself, or are you overly critical?

My self-talk used to be extremely critical, but I was completely unaware of it. Like many people, I didn't realise it was impacting my confidence, as it was such a habit. Our thoughts can be so automatic. I see this frequently in many of my high-achieving coaching clients too. In reality, it's practically impossible to feel confident (or happy!) if our self-talk is negative because our thoughts and feelings are connected.

Therefore, to boost our self-confidence we must engage in positive and empowering self-talk. Talk to yourself the way you would talk to someone you really care about. We would often never dream of speaking to others the way we speak to ourselves!

Remember, our thoughts – whether positive or negative, supportive or critical – influence our feelings, behaviour and results.

Strategy 2: Focus on your strengths more than your development areas

> *"Success is achieved by developing our strengths, not by eliminating our weaknesses."*
>
> — Marilyn vos Savant

Recently, I was coaching a senior manager, and asked her to share her strengths with me. She smiled and said, "I'm not sure. I will need to think about it." However, in the same coaching conversation, she

was able to quickly reel off a list of things she felt she needed to work on. She was incredibly smart, hard-working, self-aware, and keen to learn, but like many of us, she undervalued her amazing strengths and was preoccupied with her development areas.

To strengthen our confidence, we need to find balance by focusing on our strengths as much as (if not more than) our perceived weaknesses. Let's face it, we all have strengths *and* development areas. And while it's good to want to improve our development areas, positive psychology shows that when we focus on our strengths more than our weaknesses, we feel more confident and perform at a higher level.

Gallup, a world leading analytics and advisory firm, examined the potential gains of a strengths-based approach. It revealed that people who used their strengths every day were three times more likely to report having an excellent quality of life, six times more likely to be engaged at work, 8% more productive and 15% less likely to quit their jobs.

I was recently applying this at a practical level with one of my coaching clients, by encouraging her to focus on "strengthening her strengths" rather than fixating on her weaknesses. By doing this, she felt happier and more confident, and she also reported that she performed better.

So, when it comes to confidence, focus on your strengths and find opportunities to express them in your career or business.

Strategy 3: Watch out for comparisons

"We are all special. We are all worthy. We are all capable of greatness."

— Carrie Green

An excellent strategy for boosting confidence is to stop comparing yourself to others. How are you with comparisons? I know when I am working with a client on confidence, "comparisonitis" is often lurking in the background.

The truth is, we all have a mix of strengths and weaknesses. We experience achievements and challenges in different areas of our careers and lives. To strengthen confidence, we need to focus on our own game and achieving our personal best, rather than negatively comparing ourselves to others.

In the modern digital world, it is essential that we stop comparing ourselves to others online. The reality is that a lot of what gets shared online is a "highlights reel." And if you aren't aware of it, you can end up with a severe case of comparisonitis and feel bad about yourself. To combat this, give yourself permission to unfollow posts or updates that trigger your self-doubt or make you feel bad. Quietly hit snooze or unfollow – it's about self-care. Spend less time online or on the platforms that feed your self-doubt. Like everything we cover in this book, it's about getting to know yourself, understanding what works for you, and identifying what you need to thrive.

Remember that your self-worth has nothing to do with others, so drop the comparisons and instead focus on being your best self. Live up to your own definition of success, or as Elizabeth Nolan, one of my inspirational guests on *The Psychology of Successful Women* Podcast quoted: "Don't measure yourself against someone else's ruler."

Strategy 4: Supportive people, networks and environments

"Seek connections that make you feel seen, understood and valued."

— Chopra

The people we hang out with impact how we feel about ourselves, our careers and life in general. These people include our colleagues, clients, friends, family and wider network.

So, where possible, choose to surround yourself with supportive people who are genuinely happy when you succeed. People you trust. People who believe in you and would mention your name if an opportunity arose. People who understand you, shine a light on your strengths and encourage you to believe in yourself.

Who supports you on and offline?

Be mindful of spending too much time in environments and around people who don't support you, understand you or bring out the best in you. We are all different and unique, so it's about finding our tribe and feeling a sense of belonging.

Often, we click with people who have similar values, passions or interests. So, join a network of like-minded people for personal and professional support and inspiration. Protect your confidence and energy by surrounding yourself with supportive people and immersing yourself in environments that help you flourish. Remember, energy is contagious!

Who are your biggest supporters? Who makes you feel seen and heard? Who deeply believes in you?

"Surround yourself with the dreamers, the doers, the believers, and thinkers; but most of all, surround yourself with those who see greatness within you, even when you don't see it yourself."

— Edmund Lee

Strategy 5: Believe in yourself – validate yourself

"Believe in yourself! Have faith in your abilities! Without a humble but reasonable confidence in your own powers, you cannot be successful or happy."

— Norman Vincent Peale

What do you believe about yourself and your abilities? What do you see as a possibility for your career or business?

What we believe about ourselves at a deep level has an impact on our behaviour and our results. People who have strong, authentic self-confidence deeply believe in themselves and what they are capable of. They have faith in their abilities and all they bring to the table. Furthermore, that deep, inner confidence is not easily shaken by outside opinions or external events.

Previously, when I was a full-time dancer, I really struggled with self-confidence. Even though I had learned how to act confident on the dance floor, I didn't feel confident internally. I was totally reliant on external validation, and my confidence and self-worth bounced up and down based on a judge's score and people's feedback (who doesn't crave a perfect 10?!). I was a complete perfectionist, and I hadn't yet developed any practical strategies to pick myself back up if I took a knock.

Believe in yourself. Accept yourself. It's not our job to prove ourselves to everyone.

Time for full transparency. I am not saying I don't still have days when my confidence dips – because it does, and who doesn't love praise and compliments? But if our confidence is highly dependent on other people or external factors, then it is out of our control. It means if people do certain things, like give us praise or positive feedback, then we feel encouraged and validated. But if they don't, our confidence can plummet. Depending on your work environment or your boss and colleagues, this can cause our confidence to bounce up and down.

Of course, there is nothing wrong with enjoying positive feedback and encouragement, and none of us are immune to other people's judgements. However, we need to learn to believe in ourselves at a deeper level – a level that is not so easily influenced by external sources and the opinions of other people, many of whom don't even know us. The more you can find internal strategies or sources of confidence the better – as nobody can take them away from you.

"The woman who does not require validation from someone is the most feared on the planet."

— Mohadesa Najumi

Start telling yourself that you are enough – because you are! Remember, the most important opinion is the one you have of yourself, so focus on being the person you want to be and living up to your own standards. Start to believe in yourself, your strengths, and your abilities at a deep level. And when you do, other people will, too.

Summary:

Self-confidence is key to accelerating your career and boosting your success. The great news is there are lots of things you can do to strengthen your confidence. Engage in positive and supportive self-talk and drop the comparisons. Don't wait for other people to notice your brilliance and give you permission to step up and shine. Start backing yourself, be courageous and go for what you truly want. Authentic confidence is an inside job, and when you increase your self-belief, it will have an amazing, positive ripple effect throughout your life and career.

KEY TAKEAWAYS:

1. Engage in positive and supportive self-talk.

2. Focus on your strengths more than your weaknesses.

3. Drop the comparisons and focus on being the best you can be.

4. Surround yourself with supportive people and find environments where you thrive.

5. Believe in yourself and validate yourself.

"A dream without a plan is just a wish."

— Katherine Paterson

Stand Out from the Crowd and Accelerate Your Success

"Courage starts with showing up and letting ourselves be seen."

Brené Brown

I remember a defining moment back in 2015, when one of my clients asked me why I didn't share more about my previous career as an international ballroom dancer. I responded by saying it was a long time ago, and I didn't really think people in the business world would care all that much. Furthermore, couldn't it be perceived as 'showing off'? I personally thought that my clients would only be interested in my experience as a speaker and coach, or my background in psychology.

However, my client, who worked for a leading professional services firm, thought the opposite. She believed my dancing career was an important differentiator that helped me stand out in a competitive market. She said the fact that my partner and I were ranked sixth in the world as Ballroom and Latin American 10-Dancers, also showed that I'd really excelled at something. It proved I had lived experience of high-performance on the world stage. She believed I was undervaluing myself and playing small (like many women do), and that I should start sharing more from my dancing career and experiences competing for Australia. She assured me that people would be interested, and it was a unique aspect of my personal brand – and she was absolutely right.

What I personally realised that day, and what I see playing out with many of my clients, is that many people consciously or subconsciously undervalue their uniqueness, strengths and gifts. Sometimes we don't even know what our clients and colleagues most appreciate, respect or value about us and our work. What do your clients and colleagues most appreciate and respect about you?

Personal branding and professional success

What is a personal brand?

A personal brand is how people see us and what we become known for. It's the common words and associations that spring to mind when people hear

our name. Whether we know it or not, and whether we like it or not – we all have a personal brand.

> *"Your personal brand is what people say about you when you are not in the room."*
>
> — Jeff Bezos

Why is personal branding important?

When it comes to your career, building a strong personal brand is key to your success. It's important to consider how you are showing up and presenting yourself online and offline to ensure you are coming across in the way you would like to be seen.

Analysing and refining your personal brand can help you:

- Build trust, credibility and respect
- Attract opportunities and open doors
- Increase your influence and impact
- Take your career or business to the next level
- Ensure you don't get overlooked for opportunities or promotions

> *"A brand is a promise."*
>
> — Walter Landor

How can you build a strong and authentic personal brand?

1. Analyse your personal brand

It is important to spend some time analysing what you bring to the table both professionally and personally, and what makes you memorable or different in your sector or industry. If you want to stand out, you need to build a strong personal brand that taps into your strengths, passions, values, unique selling points and resonates with the people you most want to work with.

As a starting point, I encourage you to spend some time reflecting on:

- Your personal and professional strengths
- What makes you unique
- Your achievements and qualifications
- Your life experiences
- Your values and the things that are important to you
- Your passions
- Your image
- Your mindset and attitude
- Your behaviour

For example, think about your personal strengths. What are some of your positive qualities and attributes? Are you a people person? Maybe you're naturally positive and optimistic? Do you find it easy to build rapport or empathise with others? Perhaps you're a born connector? Maybe you're really adaptable,

flexible or open-minded? Don't underestimate your personal attributes as they are often the very reason that someone will choose to work with you over someone else.

Similarly, what are your core values? What are your interests? What are you passionate about? I have always been passionate about equality – not just gender equality, but all forms of equality. Over time without any conscious effort these values have become a natural part of my personal brand. I now do a lot of work around gender equality, diversity and inclusion, and also support charities with similar values. We all value different things – so think about your values and how they could become a part of your personal brand.

The better you know yourself, and your personal brand attributes, the better you can position and market yourself authentically to stand out from the crowd.

2. Embrace your uniqueness

> *"You are unique. That is your superpower."*
>
> — Mel Robbins

We all have our own personality, skill set, qualifications, life experience, energy, 'vibe', values and image. Yet we often tone down our differences and uniqueness in an attempt to fit in with the crowd. Sometimes we don't even realise we're doing it. However, if you look

at leading, desirable brands and products, you will see they are all striving to be unique.

There is something about these brands that is different to all the others – something that a certain section of the market is really attracted to. To be successful in the world of business, it's important to embrace your uniqueness and consider what you have to offer that is different to other people.

What's your unique selling point or USP?

How could you accentuate your uniqueness? It doesn't have to be a one in a million thing – just something that is memorable, perhaps a little different to others with a similar role or business. I always encourage my clients to leverage and accentuate, rather than hide or minimise, their uniqueness. When it comes to business, people buy people, so think about what makes you, YOU!

3. Play to your natural strengths

> *"Strength lies in difference, not in similarities."*
>
> — Stephen Covey

To build a strong and authentic personal brand, it's key we uncover and then play to our natural strengths. If you read any book on high-performers or elite athletes, they all say that they identified what they

were good at, or what they naturally excelled at, and worked with those strengths to make them even stronger. It takes way less energy, it creates less stress, and it can help you to build your authentic brand. I love helping my clients discover their natural strengths and uncover the possibilities of building their personal or business brand around the things they genuinely like doing and that come naturally to them.

What are your professional strengths?

Our strengths are often the things we really enjoy doing! These could be the things you write in your CV or your LinkedIn profile, and they often dovetail with your professional skills, qualifications and achievements.

I remember chatting with a long-term client of mine in 2019 when I was thinking of launching *The Psychology of Successful Women* Podcast. I asked if she thought it was a good idea or not as she knows me really well and understands my industry. She thought it was – as it tapped into my passions and skill set as a speaker and coach – and might be a lot of fun too. She was the spark I needed to go do it!

What do you enjoy doing? What comes naturally to you? How could you build that into your personal brand? If you're not sure, ask your clients and colleagues.

4. Seek feedback on your brand

When it comes to personal branding, feedback tells us how other people really see us. It lets us know if we are coming across in the way we would like to be seen and it helps us uncover our strengths, development areas and potential blind spots. So, consider these three simple questions:

a) **How do people see you?**

Find out how your clients and colleagues see you. Ask them what they think your strengths, positive attributes and USP are. Similarly, ask them where they think you could improve or develop to be even better.

b) **How would you like them to see you?**

Your brand should grow and evolve over time, so now think about your ideal brand perception. What would you love your clients and colleagues to say about you? How do you want (or need) to be seen to achieve your goals? For example, if you want a specific promotion in the future – think about how you would like people to see you as a leader, a senior associate or a partner. If you run your own business, think about how you would like to be seen by your ideal clients and target audience.

c) **What are the gaps?**

Once you have sought some feedback from your clients and colleagues, and have considered your ideal

brand perception, identify the gaps between the two and work on them. Spend some time digging deep into those development areas around your personal brand and how people see you.

What happens when we receive conflicting feedback?

Many people over the years have asked me how to handle conflicting or contradictory feedback. What happens when you get different opinions, comments or feedback and you don't know what to take on board?

If you are not sure what to do with some feedback you have received, speak to people you deeply trust. People who understand your role, industry and clients. Also think about the feedback in relation to your goals, values and what you are trying to achieve.

It's really important to be open to feedback, to listen to it with an open mind and never be defensive. However, you can be discerning about the feedback or advice you choose to act on. Especially if it's an outlier, rather than a pattern or recurring theme.

If you try to adapt to every single comment, opinion, or piece of advice you receive, no matter who it is from, you could stop doing the very things that your core clients or target audience LOVE about you. Sometimes people offering feedback can have your best intentions at heart, but might not understand the context of your role, clients or industry.

*"I can't tell you the secret to success,
but the key to failure is trying to please
everyone."*

— Ed Sheeran

I was speaking to a successful female entrepreneur about this, and she said she often gets conflicting feedback and advice, as everyone has their own opinion and personal preferences. However, she reminds herself that it's impossible to please everyone, and that we will always be too opinionated, too emotional, too quiet, too loud…'too much of something' for someone.

Summary:

*"We are gifted in a unique and important
way. It is our privilege and our adventure
to discover our own special light."*

— Mary Dunbar

Spend some time analysing and developing your personal brand. It's about authenticity, playing to your strengths and being the best you can be. You are different for a reason, and you have your own special contribution to make to this world. I encourage you to dig deep and bring more of your personal story to your career or business. When you truly embrace your uniqueness, you will not only be happier, but you will also attract greater success. Be you and shine bright!

KEY TAKEAWAYS:

1. Analyse your brand. Spend some time analysing who you are and what you bring to the table.

2. Embrace your uniqueness. Think about what's unique or different about you.

3. Play to your natural strengths. Authenticity is key.

4. Seek feedback. Find out how your clients and colleagues see you. Uncover your strengths and potential development areas.

"What I know for sure is that speaking your truth is the most powerful tool we all have."

— Oprah

CHAPTER THREE

Overcoming Imposter Syndrome

"There are still days when I wake up feeling like a fraud. Not sure I should be where I am."

— Sheryl Sandberg

Do you ever doubt yourself or feel like a fraud at work? Could imposter syndrome be holding you back in your career? Is imposter syndrome more common among high-achieving women?

Imposter syndrome is something that I've personally experienced at different points in my career, and it rears its head with many of my high-achieving coaching clients. The insidious thing about imposter syndrome is that even when we succeed and achieve our goals, we often still feel that we are undeserving in some

way. We may feel like we were just 'lucky' or in the right place at the right time, or that we just worked harder than other people, rather than owning and recognising our abilities and successes.

> *"When I won the Oscar, I thought it was a fluke. I thought everybody would find out, and they'd take it back. They'd come to my house, knocking on the door, 'Excuse me, we meant to give that to someone else. That was going to Meryl Streep.'"*
>
> — Jodie Foster

What is imposter syndrome?

Imposter syndrome is often described as a pervasive feeling of self-doubt, inadequacy and incompetence, despite evidence of success. The term was first coined in the 1970s by clinical psychologists Pauline Clance and Suzanne Imes who observed what I still see today – that many high-achieving women feel they are not as capable or competent as others seem to think they are. As a result, many suffer from persistent self-doubt and a sense of intellectual fraudulence. Despite their career and professional achievements, they question their skills and ability, and attribute many of their successes to luck.

How often do you discount your accomplishments? Do you ever feel like you don't deserve the success

that you currently have? Do you have a fear of being "found out"? If so, you are not alone.

Imposter syndrome can affect anyone, but research does indicate that successful and high-achieving individuals often experience it the most. Several studies have also shown that women tend to experience it more than men, especially if you work in a male-dominated or highly competitive industry.

In my career as a high-performance coach and consultant, I've come to realise that imposter syndrome is very common and often very subtle. It is not always obvious, and we can easily start to believe the imposter thoughts and feelings as truth without questioning them.

"I have written eleven books, but each time I think, 'Uh oh, they're going to find out now.'"

— Maya Angelou

I remember one of my female clients, let's call her Sophie, who had a senior role in a global consulting company. She told me that her accomplishments were due to her "catching some lucky breaks" and being in the right place at the right time. Nothing of her intelligence, experience or abilities. Even though Sophie was highly qualified, with a seriously impressive CV and track record, she didn't personally feel deserving of her success and often felt like a fraud in the workplace. Can you relate?

When I talk about imposter syndrome in my programs or keynote presentations, I always see nodding heads and knowing smiles from people in the audience. Often people will approach me afterwards to say that recognising imposter syndrome as a 'thing' and being able to put a label on it, has offered them clarity and support. It helps to normalise our feelings and fears when we realise that we are not the only ones experiencing this.

How can imposter syndrome negatively impact our career?

Imposter syndrome can hold us back in numerous ways:

- It can prevent us from applying for a promotion or dream role because we don't feel capable (although we meet all the criteria)
- It can hold us back from speaking up and having our thoughts and opinions heard in meetings or on calls (because we doubt our intelligence and abilities)
- It can lead us to become workaholics (because we feel we need to overcompensate for our lack of ability)
- It can impact our confidence and resilience
- It can lead to huge amounts of extra work and stress as we feel we must overcompensate for not really being as capable as people seem to think we are

I also hear many amazing, highly capable and experienced women say they just need some more – time, training or qualifications, before they can do 'that thing' they really want to do.

What triggers imposter syndrome?

Imposter syndrome can rear its head at any time in our career, but a promotion or a career move can often trigger it… and that's what happened to me.

Not long after I moved to London in 2006 to pursue my dream of working internationally as an inspirational speaker and coach, I applied for an exciting job as a performance coach for a consulting firm. I remember how nervous I was even applying for the role, as I felt like it was everything I had been wishing for. I knew in my heart that I would love the role, the international travel, and the opportunity to work with large groups of people and help them achieve their goals. However, as I started working through the application process and preparing for my face-to-face interview and presentation, I remember how the imposter feeling started to creep in.

I started questioning whether I was qualified, experienced or talented enough, even though I met every criteria on the application form. "Am I really good enough?" I asked myself. Maybe I was wasting my time and their time even applying?

I remember having an interesting conversation with a new UK friend the day before the job interview.

41

I was stressed out and practicing my presentation non-stop. They said that as I was "fresh off the boat" from Australia, they really admired me for going for the job, but to not feel bad if I didn't get it. No doubt it would be a very competitive process and there were lots of experienced coaches in London. Ermm... thanks for the encouragement and vote of confidence! Needless to say, my imposter feelings were at an all-time high the next day as I went in to deliver my 15-minute presentation to the CEO of the company – in front of all the other candidates too! Gulp.

The actual presentation was a bit of a blur, but I remember thinking afterwards, "Oh well, it was a long shot, but at least you tried." However, fast forward a couple of weeks and I was absolutely over the moon when the CEO phoned to tell me I had been successful, and the job was mine. I remember calling both my sisters in Australia and crying tears of joy as I felt this was the beginning of a huge goal of mine about to come true. I had been dreaming about being a motivational speaker and working internationally, helping other people achieve their goals for many, many years. After I hung up the phone however, I remember the joy left and the fear and imposter syndrome kicking in so strongly that I almost had a panic attack.

Had I oversold myself? Could I really do this? What was I thinking to even compare my previous experience with groups of mostly 10 to 20 people, to working globally and delivering keynotes (which I had never

really done) to hundreds of very senior people! Like, seriously Shona, what were you thinking? I hardly slept at night in those days before my new job began.

When I first started out in the role, I truly believed I had just been in the right place at the right time, that maybe they liked me and my Aussie accent or style, and that it was in no way due to my abilities, qualifications or experiences as a dancer, trainer and teacher. I remember feeling on edge and like a classic imposter for the first few months, as I felt so far outside my comfort zone.

However, it turned out that my previous career as a competitive ballroom dancer had taught me many skills that I didn't realise would be helpful in my new role – especially the power of body language, personal impact and performing under pressure. Even though I was often totally freaking out on the inside, it seems that I didn't really show it when I was speaking to large groups. Thankfully, over time as I got more experience and settled into the pace of London and my role, the imposter syndrome feelings slowly went away.

The powerful lesson that I learned from that experience is one I now help many of my clients with – and that is to not let the imposter thoughts and feelings hold us back. If we do, we can miss out on the most amazing opportunities and some can be truly career or life changing. I also know if I hadn't been through that experience, I would not be able to help my clients as practically and authentically – as they know that I have personally been there.

How can we tackle imposter syndrome to ensure it doesn't hold us back?

Strategy 1: Identify your triggers – become aware of your imposter thoughts and feelings

When it comes to making a change, awareness is always the first step. Learn to recognise your imposter thoughts and feelings when they emerge. Become aware of the specific situations or environments in which the imposter thoughts start, so that you can begin challenging them and changing them. What situations trigger your imposter feelings?

One of my clients discovered that she felt like an imposter in very corporate or professional environments because, like me, her family didn't come from the corporate world. During our conversation, she realised that some specific situations and environments triggered those imposter feelings in her as they were unfamiliar, and she felt like she didn't belong. Research shows that being a first-generation professional is one of the many things that can cause imposter syndrome. Other triggers may include working within an organisational culture that feeds self-doubt, or being in any environment that feels foreign to us, or where we don't fit in with the "norm." This may include, but is not limited to, age, gender identity, education, ethnicity, culture or socio-economic background.

Armed with this knowledge, leaders and managers can be on the lookout for this in their teams and do their best to support people who may be feeling like an

imposter or like they don't fit in. It is critical to create psychologically safe, open and inclusive environments.

Strategy 2: Acknowledge your past successes and accomplishments

"There is a past version of you that is so proud of how far you have come."

— Theopeninvite

Look at your CV, re-read your LinkedIn profile and look at all the amazing things you have achieved. Make a list of your successes and achievements to remember how far you've come. It's good to see them in writing so that they can really start to sink in. When you make a written list, you can also refer back to it whenever you start questioning your abilities or need a boost.

Many of my clients have "aha" moments or start laughing when I have asked them to do this exercise with me. They quickly realise they have achieved way more than they can even remember! Clients will often say to me, "I completely forgot about that training course I completed" or "I forgot about that important project I worked on." They usually don't give themselves credit for the amazing things they've done. Try it!

I often encourage people I am coaching to keep a file of positive feedback and comments from their

colleagues and clients too. This also comes in very handy for their performance reviews.

Don't minimise your successes or discount your achievements to things outside of yourself. Own them and internalise them. Feel proud of yourself because you earned them. Really let all those good things sink in. Remember that your imposter syndrome feelings are not real and tangible, but your successes and wins are. Linked to this, when people give you a compliment, don't dismiss or ignore it: learn to say thank you and allow yourself to receive it.

Coaching Activity:

- Write a list of some of your achievements and successes.
- Reflect on some of the great feedback you have received from a client or colleague in the past few months.

Strategy 3: Back yourself and challenge your imposter thoughts

Our thoughts and our beliefs impact how we feel. So instead of thinking you don't deserve your success, or you don't deserve to be in a certain role or situation, reassure yourself that you absolutely deserve to be there. Tell yourself that you are worthy of your success and that you are good enough. Remember that you would not have received the promotion or been asked

to do something if other people did not think you were capable.

On *The Psychology of Successful Women* Podcast, when I spoke with Jo Gubbay, who has held Learning and Development roles at international law firms, she described this issue perfectly:

> *"….many women that I've come across, actually underestimate themselves… You know, they lack confidence in the workplace, and they suffer from imposter syndrome. Well, let me tell you, after 35 years, I still suffer from imposter syndrome. When you asked me to do this podcast, my first reaction was 'I don't have anything to say.' And then my daughters, they told me that I was 'wisdomous' – which was the word that they coined – and they reminded me of all the advice I've given them over the years."*

Remember it is completely normal if you don't feel confident or know everything at the beginning of a new role or project. Learn to trust yourself and remember that you will learn, improve and feel more self-assured as you progress.

Strategy 4: Talk to someone about your imposter feelings

When I first started keynote speaking, I remember asking myself, "Who was I to be there?" or "Who was I to be talking to these very senior, experienced

'corporate people' about success psychology and peak performance?" Thankfully, my coach at the time reminded me that I was the expert in these areas, just as my clients were experts in their chosen fields. Furthermore, they would not have booked me if they didn't believe in me. My coach also told me that she had struggled with imposter syndrome in the past. So, talk about your feelings with a coach, mentor or someone you trust who won't judge you, and you will realise that many people have felt this way. It also doesn't mean those imposter feelings are a true reflection of your abilities.

Finally, don't fall into the trap of thinking you must be perfect or the absolute best in your industry to justify your place there. Claim your space and focus on being you, helping your clients, sharing your knowledge and adding value. It can be hard to think of ourselves as experts if we keep comparing ourselves or our career journey to other people who have a different skill set, may be at a different stage in their careers or be on a completely different path.

Summary:

Imposter syndrome is extremely common – especially in high-achievers. So, the next time you feel like an imposter, I challenge you to pause, take a deep breath and remember that you are more than capable. Give yourself credit for how far you have come and know that you would not have achieved success if other people didn't believe in you. Often, we don't even

realise the subconscious skills and abilities we have in our "tool kit" until we have to draw on them. Trust yourself and remember – just because you might feel like an imposter sometimes – doesn't mean it's true!

KEY TAKEAWAYS:

1. Be on the lookout for imposter syndrome. When do you experience those thoughts and feelings? When do you feel like a fraud? In what environments do you feel triggered?

2. Acknowledge and write out your past successes and achievements. Look at them and refer to this list whenever you start questioning your abilities and need a confidence boost.

3. Talk with someone you trust about your imposter feelings.

4. Back yourself and challenge your imposter thoughts. Remember, just because you feel like an imposter doesn't mean you are one.

"Connection is the energy that is created between people when they feel seen, heard and valued; when they can give and receive without judgement."

— Brené Brown

CHAPTER FOUR

It's All About Relationships

"Succeeding in business is all about making connections."

— Richard Branson

What practical steps can you take to build a strong and supportive professional network? What qualities and attributes make a person good at networking? Which networking activities best suit your goals and personality?

Whether you are searching for a new job, wanting to connect with other people for support or inspiration, developing your profile, or wishing to find clients and grow your business, having a strong network is vital to your success. While many people know on a logical level that networking is important, it often gets overlooked or

drops to the bottom of the list of competing priorities. Life gets in the way; we get busy and forget to take consistent action to build and nurture our network.

Most people I have met in my professional career don't truly realise the importance of networking until they really need it. Sometimes it takes a trigger like a career change, a restructure, potential redundancy or even starting their own business for the value of a strong professional network to really kick in. The key is to build your network before you need it and the earlier you start the better.

> *"Networking is a lot like nutrition and fitness: we know what to do, the hard part is making it a top priority."*
>
> — Herminia Ibarra

In the dynamic and interconnected world of business, our professional network can make all the difference when it comes to succeeding and thriving, both now and in the future. Take a moment and think about how building your network could help you right now in your career or business. There are so many benefits of networking, and some of the most popular themes that come up with my clients include:

- To uncover opportunities
- To support career advancement and promotions
- To build your brand and boost your profile

- To gain knowledge, new perspectives and fresh ideas
- To foster collaboration and spark innovation
- For career or business advice
- Your personal and professional support system

In the jobs market, some experts say that 70% of all vacancies are not publicly advertised, and as much as 80% of roles are filled through personal and professional connections – where the ideal candidate has already been chosen behind the scenes. In the ever-changing world of work, the importance of networks in having a successful career only stands to grow. LinkedIn Executive Chairman Jeff Weiner has dubbed this the "network gap".

Building your network

The great news is - there are lots of things we can do to build strong relationships and grow our network and client base. Remember – people choose to work with those they know, like and trust.

1. Find your preferred style of networking

When it comes to networking, I am all about helping my clients find the path of least resistance. You need to find a style of networking which is enjoyable for you. An approach that suits your personality, lifestyle, goals and objectives.

How do you like to network? What is your preferred style?

- Do you love one-to-ones? Coffee meetings, calls and Zoom catch ups?
- Do you prefer bigger professional networking events or conferences?
- Do you thrive in more formal, structured networking groups or networking lunches?
- Do you like connecting with people online and via social media?

Everybody is different, but by uncovering and working with your natural networking style and approach, you are much more likely to take action and enjoy it! It really doesn't matter if you are an introvert or an extrovert, we just have to find a way that works for us and then commit to taking consistent action.

People who don't know me will often assume that because I do a lot of public speaking that I must be a natural extrovert – but I am actually more introverted. That is probably why I prefer small groups and private, one-to-one catch ups. I will always choose a personal catch up by phone or face to face, over a larger event or group situation if given the choice. Furthermore, I also need time alone to rest and refuel after social activities and all my speaking events.

Does this mean I never go to big events? Of course not, but my mix of networking activities lends more to deep conversations and one-to-ones.

2. Join a network

There are so many great networks out there. Find a network that you feel a connection with, where you've got things in common with people involved. It could be an internal networking group or an external one, or a combination of both. I'm a member of lots of networks that support women in the world of business, because it's obviously a huge passion of mine. I am also a member of several professional associations and online groups for inspiration and connection. As a woman in business there are so many options and possibilities right now. The list is ever growing and we are all different, so it is up to you to consider what you value and the sorts of networks both online and offline that you feel a genuine connection with.

If you work for a company, don't underestimate the power of joining an internal network, volunteering for a committee, putting your hand up to introduce an event or speaker, or to help promote company events. All of these are great for growing your network and your profile.

If you are a business owner or entrepreneur – find networks that suit your passions and needs, somewhere you can go for inspiration and support, or to give back. Also think about where you ideal clients may hang out so you can find people who are genuinely looking for what you have to offer.

3. Embrace informal networking opportunities

"You can make more friends in two months by becoming interested in other people than you can in two years by trying to get other people interested in you."

— Dale Carnegie

Never underestimate those 'watercooler' moments, the informal conversations in the lift, on conference calls before the session officially starts or when you bump into people in the office. A lot of people just think of networking as part of formal situations and events, but we have opportunities to network and build relationships all the time.

Some of the biggest work opportunities I have ever had occurred in completely random situations when I wasn't even thinking about work! So be open and genuinely interested in people, be a good listener and ask questions. Look for ways to help others and add value. Opportunities can come from anywhere and anyone.

4. Be generous – give first

Generosity is key and all the best networkers I know are very generous. They always invest time and energy in building a relationship first, and adding value, before asking for anything in return. So, a key

aspect to building your network is to be generous with your appreciation and support of others. Focus your attention on what you can give first, before asking for help.

Be generous in connecting other people and show your appreciation when people help you, promote you, or make introductions for you. It's also a good idea to keep people updated on progress following an introduction they have made for you. Shine a light on others online and offline. Help others achieve their goals. The funny thing is, when you have a generosity of spirit and support others, many will naturally want to return the favour and reciprocate.

I remember when I first started my busines in the UK. A woman I had met only a few times before kindly went out of her way to introduce me to several senior people in global companies who ended up becoming long-term clients. She genuinely loves connecting people and is always looking for those who might be able to help each other in business. I learned so much from her about networking and connecting others. We are still great friends today.

- Who do you know that is a generous networker? How could you help each other?
- Who could you support or shine a light on in your network this week?
- Who have you connected or introduced lately?

5. Think long-term not short-term

Building trust takes time, so when it comes to relationships and networking, I always encourage my clients to think long-term. I have always personally believed in building up strong, long-term relationships and I have built my business mostly through one-to-one connections, referrals and introductions from clients.

As a high-performance coach and inspirational speaker, I love working with organisations over many years and getting to know their culture and feeling a part of their team. Similarly, I tend to work with coaching clients for at least six months, and my *Career Acceleration Program* is also spread over several months.

My work and personality style both suit deeper, longer-term, sustained relationships. Not surprisingly, I tend to attract clients who are also looking for that. We often attract people to us who hold similar values and principles.

6. Be positive and approachable

"People will forget what you say, people will forget what you do, but people will never forget how you made them feel."

— Maya Angelou

Most great networkers are positive people, and it's no surprise that most of us like being around people who have a positive and optimistic attitude towards life. People who are open-minded, approachable and make others feel good about themselves and life in general. A great way to build your network is to be conscious of your mindset and attitude. Look for the good in people and the positive in situations. Have a growth mindset.

When you meet someone for the first time ask questions that create positivity and make people feel good when they answer them. For example: What inspired you to start your business? How did you get your break in X sector? What's your passion outside of work? Be the reason other people feel seen, heard and valued.

I remember my first encounter with one of my clients at an event I was speaking at a few years ago. We'd not met previously, but she was so approachable, happy and genuinely interested in others. The sort of person that made you feel like you were the only person in the room. When she approached me in the networking drinks after my speaker slot, we just clicked straight away, and we've become a great support for each other ever since. Not surprisingly, we've now done a lot of work together too. When it comes to networking, the positive feelings we get from people sticks with us – but be careful, so do the negative ones!

7. Remember the 'social' in social media

Depending on what industry you work in, there are lots of platforms that can help us network: LinkedIn, Twitter, Facebook, Instagram etc. Some of my clients really enjoy social media, while others don't. Whatever your personal thoughts – platforms like LinkedIn have hundreds of millions of users, so they can be a great way to network from the comfort of your own home – for free.

The decade I was based in London between 2006-2016, I did a lot of work in the UK but also across Europe and internationally. Without a conscious plan behind it, I started to use LinkedIn. Over time, new contacts would reach out to me to connect after they saw me speak at an event or workshop and my network slowly grew. Although I didn't regularly post on the platform, I did 'like', comment and support others, and my network started to snowball as more contacts brought more contacts.

In 2016 when I decided to move back home to Australia – I realised how important it was to have established my online network. Nowadays, new clients regularly make contact or reach out to me via the platform and with COVID-19 affecting so much of the world – training, coaching and inspirational events have moved online. LinkedIn has become a great way for my clients to engage with me and for me to stay in touch and up to date with what they are doing.

Use social media to help build and maintain your network and find your platform of preference.

8. Take consistent action

A key to building your professional network internally or externally is taking consistent action. It doesn't have to be huge, time-consuming activities or tasks, but small consistent steps each week or month to build and maintain your professional network. Networking needs to be a key priority, and if we don't do this, opportunities will pass us by.

It's not just who you know, it's who knows you, who likes you and who trusts you that really counts.

What have you done in the last month to build your network online or offline? What can you do this month to build your network?

Summary:

Networking is key to professional success. If you want to build a strong and supportive professional network, find ways to support and help other people. Be positive and approachable and show a genuine interest in others. Take consistent action to both build and maintain your network, and remember that our success and fulfilment come through relationships.

KEY TAKEAWAYS:

1. Find your preferred style and approach to networking – small groups, events or online.

2. Join a network – find a network you feel a connection with.

3. Think long-term not short-term – trust takes time to build.

4. Be generous. Always give first and invest in building a relationship before asking for a favour. Support other people online and offline.

5. Be positive – make others feel valued, seen and heard.

6. Take consistent action to build and maintain your network.

"Define success on your own terms, achieve it by your own rules, and build a life you're proud to live."

— Ann Sweeney

Perfectly Imperfect

"Success has nothing to do with perfection."

— Michelle Obama

Does perfectionism help or hinder career progression? Do imposter syndrome and perfectionism typically go hand in hand? Does perfectionism increase stress and anxiety?

When I was a full-time Ballroom and Latin American dancer my life was consumed with dance practice, lessons, performing, competitions and receiving feedback. A huge percentage of my time was spent in a dance studio in front of a mirror 'perfecting' dance moves.

I was taught from a young age to have incredibly high standards and there was even a sign on the dance studio wall that said, "Practice doesn't make Perfect, Perfect Practice makes Perfect." Like

many other dancers, I learned to push myself hard physically, mentally and emotionally. Every dance move and every aspect of your performance and appearance including make-up, hair, nails – even the shine of your shoes – had to be flawless if you wanted to compete on the world stage and win championships.

I remember being incredibly hard on myself if I ever put a foot wrong (literally!), especially at international competitions, because not only was I representing my country, but it was an expensive sport, and I was acutely aware of the financial pressure it was putting on my family.

Perfectionism in psychology is described as "a broad personality style, often characterised by striving for flawlessness and perfection."

Whilst the desire or need to be perfect is sometimes viewed as a positive trait, it can have costly consequences for your career or business.

What are some of the costs of setting such high standards?

- Procrastination
- Worry, stress and anxiety
- Repeated checking of work
- Excessive amount of time spent completing tasks
- Ongoing fear of failure or mistakes

- Extreme self-judgement and self-criticism
- Saying no to opportunities which can slow down career progression

Perfectionism, stress and anxiety

One of the consequences of having extremely high standards is that it can increase our stress and anxiety, and actually make us perform worse. Such is the double-edged sword of perfectionism! Have you ever put so much pressure on yourself that you were overcome with nerves and could hardly think straight? I certainly have in the past.

Now, I'm not saying we should all drop our standards and aim for average or mediocre. As a high-performance coach, my clients are driven, smart, hardworking and want to be the very best they can be. There is a huge difference however, between the pursuit of excellence and the often unhelpful and exhausting pinnacle of perfection.

A few years back, after I finished an International Women's Day keynote, I was approached by a prospective client who asked if I could coach her on public speaking. She led a team and was super smart and successful. It transpired that until now she had been able to avoid speaking to large groups, but having just been promoted to an even more senior role, it was time to tackle her fear of public speaking once and for all. Although she knew what she should be doing in theory, when she actually got up to speak

all the knowledge went out the window and she was overcome with fear and anxiety.

It is another great example of how knowledge is not enough to create real, sustainable performance improvement or behavioural change, and a helpful reminder that it's often our mindset or fear that holds us back. When my client and I dug deeper into her mindset, her biggest fear and challenge (like with many of my clients) was perfectionism and the associated fear of failure.

"Perfectionism is a dream killer because it's just fear disguised as trying to do your best."

— Mastin Kipp

Many people I work with set the bar so high when they learn a new skill or do something for the first time that they create huge amounts of additional anxiety and stress for themselves. In fact, perfectionism is one of the biggest causes of fear and stage fright. I know this personally – because this is exactly how I used to be before I overcame my extreme fear of public speaking. More about that later in the book!

Many high achievers I meet are perfectionists and are often fighting off our old friend imposter syndrome too. These two often go hand in hand. So, how can we overcome perfectionism to make sure it doesn't hold us back from the things we want to achieve in our careers?

Overcoming perfectionism

"Perfection is the enemy of progress."
— Winston Churchill

1. Challenge the way you view perfectionism

How do you personally view perfectionism? Do you believe it's a good thing? Is it helping or hindering your career progress? Could it be impacting your confidence and resilience? What does perfection even mean, except in some sports where the aim is a perfect score? Unless you're a brain surgeon, rocket scientist, Olympian, or something similar – do you really need to be aiming for perfection all the time?

I used to believe deep in my heart that perfectionism was a good thing and wore it as a badge of honour. Maybe it did help me when I was a competitive ballroom dancer, when every dance step or move could be the difference between a judge giving me an 8, 9 or a 'perfect' 10 – however, I no longer need the same microscopic lens on most things in my life and business.

As a coach, I know firsthand that it actually slows many people down from learning, growing and having fun in their career or business. In fact, for many of my clients, perfectionism causes huge amounts of self-imposed stress. Perfectionism often leads to overdelivering, exhaustion or overthinking every decision you make. Remember, you are allowed to make mistakes. You

are not supposed to know everything or be flawless. We are all a work in progress.

2. Remember there really is no such thing as perfect

"Perfectionism is a 20-tonne shield that we lug around thinking it will protect us, when in fact it's the thing that's really preventing us from taking flight."

— Brené Brown

Done is better than perfect

What are you currently procrastinating on? Could perfectionism be at play? As a 'reformed perfectionist' myself, I always say to my clients that "done is typically better than perfect." So many people never achieve their goals or dreams because they are waiting to be perfect. The problem is that day never comes and so they never end up doing it. Perfectionism can really slow down career progression.

I have wanted to write a book for many years, but there never seemed to be 'the right time.' Even though I've been a coach and professional speaker for over 15 years, have written several e-books, and tens of thousands of words in my year-long honours thesis in psychology at university, I still had huge resistance around writing a "real book." It wasn't until I got over my own perfectionistic tendencies that I decided to make it happen this year.

Once I started the writing process, there were some days when I got completely stuck overthinking things and it was almost impossible to write. In my dancing days we used to call this "analysis paralysis!" I had so many questions and thoughts. What should I include and what could I leave out (or leave for another book)? I have developed in-depth, highly practical workshops on each of these chapters over many years, and I knew I couldn't possibly cover everything in this one book. Which strategies and stories should I highlight when I prioritise the content? Would I write this book for men and women and speak more broadly? Or would I focus on the common challenges that come up more frequently with my female clients and some key strategies from *The Psychology of Successful Women – Career Acceleration Program*?

Perfectionism often leads to overthinking and overcomplicating things!

So many options, possibilities and questions and there was no "perfect" answer. For the perfectionists reading this – I am sure you can relate. In the end I decided to just make a decision, stop overthinking it, and to focus on helping and supporting anyone who is drawn to read this book. I took the same advice I give my clients and refused to spin my wheels any longer.

Don't let perfectionism or "analysis paralysis" hold you back from achieving your goals. Focus on the impact you want to make, the people you want to help, your why, your dreams and the bigger picture. I also deeply believe when we feel called and inspired

to do something, that we should follow that calling. What are you feeling called to do in your career or business right now? Go do it!

Don't wait until you feel "ready" to do something, because if you're a perfectionist, you might never feel completely ready. Just get going, get moving in the direction you want to, and you can reflect, improve and adjust as you go. Perfectionism can hold us back from even getting started! We learn and get better through practice and taking action, not by thinking about something in theory.

> *"Strive for continuous improvement over perfectionism."*
>
> — Kim Collins

3. Aim for excellence not perfection

Remember back at school – 80% was still an A? So, think of aiming for 80% to 90% rather than 100% all the time, and be more discerning about whether a task deserves so much time, energy and attention. Perfection is an unattainable goal. We can still have high standards, but that's not the same as aiming for perfection and being so self-critical. To be honest, it's often just not worth the extra stress, anxiety and additional time we spend on perfecting the work and rechecking.

One of my role models has a thriving, global business she loves, and a great lifestyle. She credits a lot of her

success to her ability to take imperfect action and not let unrealistically high standards hold her back. She is an inspiration to many women – showing that you can be successful and have a huge global impact doing what you love, without being 'perfect.'

Ask yourself, what does perfect even mean in the world of business? **You are never going to keep everyone happy and there is always room to grow and improve.** Often, aiming for your best based on the time and resources you have is enough. Start asking yourself, 'Is this... of a high standard?' or 'Does this meet the objectives, based on the time and resources I have available to complete it?' Don't ask, 'Is this perfect?' or the answer will always be, no!

4. Drop the self-criticism

Perfectionists are often super hard on themselves. They set their standards so high and then beat themselves up if they fall short or make a mistake – even when they are learning something new. Because they are tough on themselves, they often assume that other people are looking at them or judging them in the same hyper-critical way – which makes them even more anxious. It's a self-perpetuating cycle.

Having a critical internal voice and unrealistically high standards can block our confidence, happiness, ability to express ourselves and our overall performance. Start cutting yourself some slack and be kinder to yourself. When you make peace with yourself and accept that

it's okay to make the odd mistake, not know it all, or to learn as you go, other people will reflect that back to you. You also give other women permission to show up and shoot for their dreams without the unrealistic and unachievable expectation that they must be flawless or perfect to do this.

Summary:

Where might you be holding yourself back right now in your career or business due to perfectionism? Be careful that perfectionism doesn't dampen your personal and professional growth and happiness. Please don't wait for the perfect situation or for a time when you feel completely ready, because it may never come. Embrace your imperfections. Remember, you are perfectly imperfect.

KEY TAKEAWAYS:

1. Challenge the way you view perfectionism. Be on the lookout for how perfectionism might be holding you back in your career or business.

2. Aim for excellence rather than perfection.

3. Remember that done is better than perfect: start taking imperfect action and correct as you go. We learn by doing, adjusting course and growing.

4. Drop the self-criticism. Remind yourself that it's okay to make mistakes and become more supportive of yourself. We are all a work in progress.

"In a society that says,
'put yourself last,'
self-love and
self-acceptance
are almost
revolutionary."

— Brené Brown

CHAPTER SIX

Boundaries, Assertiveness and People Pleasing

"When you say Yes to others, make sure you are not saying No to yourself."

— Paulo Coelho

Do you often say yes when you'd like to say no? Do you have challenges with setting boundaries or being assertive? Do you often compromise your own needs to keep other people happy?

I caught up for coffee with a small business owner recently who wanted to explore private coaching. I knew immediately that something was up. She's the sort of person that always delivers and that everyone comes to for help and support. One of the many reasons her business has grown so fast. She is well known, respected and liked by her clients and wider network. She has a big heart and wants to help and

give as much as she can. It became obvious during our discussion however, that because she had been giving so much of her time and energy to others, her own physical and emotional needs were not being met. She said she wasn't feeling herself and was starting to feel run down, stressed and swamped by an ever-growing list of demands. Can you relate?

Many of the remarkable women I work with express challenges around boundaries, people pleasing and assertiveness. I know these challenges all too well as I spent many of my early years in business as a 'people pleaser' until I realised it wasn't a sustainable or healthy way to be and I was starting to burn out. I would commit to more than I could physically handle and then end up exhausted or sick. I would say yes, when I really wanted to say no, because I wasn't assertive, and I wanted everyone to like me. I was raised to be nice, to help other people and to be kind. As one of four kids growing up, and the eldest of three sisters, I was used to thinking about and supporting others.

Although I didn't realise it consciously at the time, the very thought that someone might not like me, or perceive me as unhelpful or selfish, was feeding my people pleasing behaviour. I still have to watch out for this at times, both as a business owner and in my personal life.

"The only thing wrong with trying to please everyone is that there's always at least one person who will remain unhappy. You."

— Elizabeth Parker

What is a people pleaser?

A people pleaser is one of the nicest and most helpful people you know. They don't want to upset other people or let anyone down, and they hardly ever say no. You can always count on these people for a favour, and they tend to be great at compromising. In fact, they spend a lot of their time doing things for other people, often at the expense of their own needs and goals.

Now, at first glance this may sound relatively harmless, but there are a few serious consequences of people pleasing which I have observed firsthand with clients and in my own life.

Potential consequences of people pleasing:

- It can lead to increased stress or burnout from taking on more than you can handle mentally, physically or emotionally
- You can lose touch with your own emotions and needs, as you are so busy focusing on other people's needs and demands
- You may end up feeling taken advantage of or undervalued personally and

The Psychology of Successful Women

professionally, which can lead to feelings of resentment and sadness
- It could stop you from achieving your own goals and dreams because you are so busy helping other people achieve their objectives

Tools and techniques for conquering people pleasing tendencies

1. Clear boundaries and clear expectations

"You become yourself when you're willing to create boundaries that promote and protect your emotional, mental, physical and spiritual wellbeing."

— Nat Lue

Setting boundaries is a form of self-respect and self-care, but often we don't make our boundaries or expectations clear. We must learn to ask for what we want and need and not fall into the trap of assuming that other people already know or can read our minds.

How are you with clear and open communication of your boundaries?

How do you manage expectations in your career or business?

I've had to work on this as a business owner and many of my clients say this is a development area for them. I'm sure we've all experienced situations where our boundaries were vague and things didn't go to plan. Perhaps you agreed to something verbally, only to find that the parameters changed, and the expectations were then very different – classic 'scope creep.' Or perhaps someone committed to doing something and then they haven't followed through? Leaving you to pick up the pieces?

Setting clear boundaries and discussing expectations upfront, preferably in writing, is a great way to minimise this. It also means if several people are involved in the project or communication, there is an email thread available to see what was agreed. This is something that I commit to in my business, and I encourage lots of my clients to do so as well. It also means there is less room for a genuine or innocent misunderstanding.

2. Assertive communication

> *"Saying no to one thing is saying yes to the possibility of another."*
>
> — Ellie Roscher

Learn to say no with confidence and kindness. Here are some simple sentences you can use:

- Thank you for thinking of me, but I don't have the time right now.

- I'm booked up for the next month. But feel free to circle back next month.
- I don't have capacity to help you with that at the moment.
- Unfortunately, I'm overcommitted right now, but thanks for the opportunity.
- Sorry – that doesn't work with my other commitments, but perhaps another time?
- No thank you, I can't commit to that right now.

If you are used to saying yes all the time, you might feel guilty or strange saying no at first, but like most things, it gets easier with practice. Remember that if you don't learn to honour your time and boundaries, other people probably won't respect them either. Furthermore, repeatedly saying yes can lead to an overwhelming workload, and you could be at serious risk of burnout in the future – and that's not good for anyone.

3. Don't feel the need to give excessive excuses or apologies

You have the right to say no, and you do not have to explain yourself. Remember that "No" can be a full sentence and often, less is more. Have you ever spoken to someone who had a response ready for anything you said? The more you tried to explain why you wanted to kindly decline a request, the more they tried to counter the issue. Often, we can end up feeling flustered and pressured. Sometimes, it's

easier and way less stressful to just say no without the detailed explanation, or to use what psychology calls the "broken record technique."

Use the broken record technique.

Try not to feel intimidated if someone won't take no for an answer. When you've said no and they are not listening, kindly reaffirm it using the broken record technique. This is just repeating the same phrase or sentence over and over. "Again, I'm sorry, but I can't help you at the moment. I'm sorry. I can't help you right now." And don't give excuses or reasons.

Remind yourself that you don't have to explain or justify your situation and that you have the right to say no – to anything in your personal or professional life – without feeling guilty or feeling pressured.

4. Reconnect with your wants and needs

Many of my clients are so good at sensing and empathising with what other people need that they can find themselves disconnected from their own needs and goals. Learn to reconnect with your physical and emotional needs. How are you feeling? Are you feeling exhausted or burnt out? Are you engaging in self-care? Are you saying yes to too many things? Are you feeling like you have been over-giving and are starting to feel resentful or unappreciated?

If you don't frequently reconnect with how you are feeling and what you need, things can start to unravel quite quickly.

Remember some of your basic human rights:

- You have the right to be treated with respect
- You have the right to express your feelings, opinions and beliefs
- You have the right to say no without feeling guilty
- You have the right to be listened to and taken seriously
- You have the right to change your mind
- You have the right to ask for what you want
- You have the right to put yourself first sometimes
- You have the right to set your own priorities
- You have the right to refuse justification for your feelings or behaviours
- You have the right to make mistakes and accept the responsibility for them

Reflect on this list of human rights and think about which ones you need to focus on or remind yourself about.

I know for me personally, I had a real block around saying no and the right to change my mind. Due to my life experiences and previous career as a competitive dancer, I had the deep belief that once I had committed to something that I needed to stick

to it and that "the show must go on"! I would never reschedule anything and for many years I would push myself to do things even when I was exhausted, unwell or carrying an injury, because I didn't believe I had the right to change plans.

I cringe when I look back and think about how many years I put my own health and self-care second to other people's needs. Moreover, I am sure most people would have been fine with me saying no or changing plans! I encourage you to read the above list of human rights again and really let them sink in.

Challenges and fears to overcome

One of the biggest things that can stop people from setting boundaries, saying no and communicating in an assertive way, is a fear of being judged or criticised. "What if people perceive me as unhelpful or selfish?" I hear this from a lot of my clients. The truth is – when you start to set boundaries and honour yourself more – some people are probably not going to like it, especially anyone who may be benefiting from your people pleasing tendencies or lack of boundaries.

"As women we must stand up for ourselves, for each other and for justice for all."
— Michelle Obama

In reality we can't control how others may react when we clarify our boundaries. However, from my many years of experience as a coach, I can assure you that if you're worried about being seen as selfish, it's very unlikely that you are.

Remember....

Setting clear boundaries and saying no with kindness are a form of self-respect and self-care. You are also being a positive role model for other women.

Summary:

In order to avoid burnout and create a sustainable and fulfilling career or business – watch out for people pleasing tendencies. Creating clear boundaries and expectations, saying "no" and honouring your personal rights, are key to your success and happiness. They are also important for our physical and mental health. Remember, there is nothing wrong with helping people when you want to, and have capacity to do so. There is also nothing wrong with saying no, setting boundaries and honouring your needs so that you have the time and energy to build a career and life you love.

KEY TAKEAWAYS:

1. Set clear boundaries in your personal and professional life.

2. Learn to say no with kindness.

3. Use the broken record technique.

4. Remember the human rights.

5. Tap into your own wants and needs. How are you feeling? What do you want or need in this moment?

6. Drop the self-guilt.

"Inaction breeds doubt and fear. Action breeds confidence and courage. If you want to conquer fear, do not sit and think about it. Go out and get busy."

— Dale Carnegie

CHAPTER SEVEN

Feel the Fear and Speak in Public Anyway

Five Simple Strategies to Ensure Fear Doesn't Hold You Back

It doesn't matter if I am delivering a keynote, a workshop, or working with a private coaching client, the topic of fear always comes up. Let's face it, we all have fears! For some people it's a fear of being judged or criticised. For others, it could be a fear of failure, a career change or the commonly held fear of public speaking. It's different for all of my clients. There are lots of things that can stop us from chasing our goals and fulfilling our potential – if we let them.

Like many people, my biggest fear for many years was public speaking.

Many people who meet me through my speaking events often assume that I must be a natural born public speaker, but this could not be further from the truth. Although I spent my youth performing for audiences and judges as a ballroom dancer, I was absolutely terrified of public speaking! In fact, the thought of it scared me so much that I used to practically hyperventilate at school when I had to read out loud in English class. I would do anything (and I mean anything) to avoid it. My family and school friends still cannot believe what I do for a living as they remember how I used to be.

My extreme fear of public speaking continued into university where I refused to take elective courses that had a presentation as part of the assessment criteria. When I did have to do them, I would hardly sleep in the nights building up the presentation, and I even once very seriously contemplated having an alcoholic drink before a presentation to try and calm my nerves! The turning point came when I realised I really wanted to inspire, coach and teach others. When I imagined helping people achieve their goals, chase their dreams and create success – I knew this would involve keynotes, conferences and workshops, so I had no choice but to get over my own fear of public speaking.

That year I set the intention of overcoming my fear of public speaking and I now love teaching my clients how I did this. The good news is that there are many

strategies and mindset tools that you can learn and apply to work with fear. You can use these practical techniques to embrace and reframe fear, rather than be blocked and paralysed by it.

1. Reprogram your mindset

Our thoughts and beliefs impact how we feel. In order to overcome our fearful feelings, we need to spend some time digging into our thoughts and beliefs about the very thing we are afraid of. At a very real level, in order to change how we see things, we need to change our mindset.

So, using public speaking as the example, consider the thoughts and beliefs of someone who is terrified of public speaking.

- How might they view public speaking?
- What might they say to themselves when they are about to walk on?
- What do they worry about?
- What kind of pressure might they put on themselves?

I know from personal experience and from helping many individuals overcome this fear in my programs, that most of their answers to the above questions are typically negative and fear based.

Now, consider the thoughts and beliefs of someone who isn't fearful of public speaking. Even more – think

about the mindset of someone who genuinely enjoys speaking to groups.

- How do you think they see public speaking?
- What do they believe about it?
- How might they see their audience?
- What do you think they say to themselves when they are about to walk on?

Are they mostly positive and empowering thoughts? Or negative and fear-based thoughts?

Comparing the two examples above, they have very different thoughts and beliefs – very different mindsets. These different mindsets lead to different feelings, behaviours and results.

Changing thoughts and beliefs

Unless we change or reframe our limiting thoughts and beliefs, it can be really hard, if not impossible, to reduce the fear. If you don't do the inner work on your mindset, and instead only try and change things at an external or behavioural level, you'll still feel nervous or experience fear on the inside. This is because your mindset and behaviour are not yet aligned. I know first-hand as this was the case with me for many years with public speaking. I knew all the theory, but I couldn't do it in practice.

Until I made the true inner shift, identified my unhelpful perceptions and reprogrammed my mindset, my

irrational fear didn't go away. My performance coach in London played the biggest role in helping me overcome my fear as we worked deeply on my mindset and psychology to uncover my specific blocks and deeply held beliefs, not just my behaviour.

If there is a specific fear you would like to overcome and you are struggling on your own, work with someone on your mindset. Often, we can't pinpoint our own disempowering beliefs, or see our blind spots. Once you identify the root cause of your fear and start to shift it, your fear will begin to dissipate.

2. Change your language

Are you excited or scared?

Language is powerful. It impacts how we feel and how we perform.

Have you noticed the way Olympians react when asked how they are feeling before a race or event? They will never say they are nervous or apprehensive.

Reporter: *"So you've been training and building towards this for the last four years, and tomorrow it all begins. How are you feeling about the race?"*

Olympian: *"I'm excited. It's what I've been working so hard for. A chance to show the world what I can do. I can't wait to get out there."*

Notice this the next time a sportsperson is interviewed. They will always say a version of 'I am excited, ready, looking forward to it.' In the world of peak performance, we call this "psyching yourself up." It's a total commitment to positivity in both thoughts and visualisation. I used to do this for days before big world championships and I was super conscious of this right before I walked out into the arena. Positive thoughts and positive language help us perform at our best.

If you want to feel more confident with a specific task or in a certain situation, and reduce your fear, a great strategy is to stop saying you are afraid of it. Stop reinforcing it. Every time you say "I am dreading it," "I can't wait until it's over" out loud – your subconscious mind hears you. Just like a positive affirmation can help create a positive emotion and a positive change, a negative affirmation can keep our fears in place. By consciously taking control of your language, you build belief and a positivity that will help you feel good and perform at your best.

3. Feel the fear and take action

"Feel the fear and do it anyway."
— Susan Jeffers

A practical, behavioural strategy for dealing with fear is to take action and stretch your comfort zone. Do the thing you're afraid of doing.

Like many of my clients – as my career has progressed and my business has grown – there have been many new fears I have had to confront. I recall the nerves when I did my first big keynote presentation in 2006 to a room of London's top bankers. And then again when I started my business, it took everything I had to take the leap of faith and leave a regular salary. More recently, the first time I recorded *The Psychology of Successful Women* Podcast my fear and perfectionism were kicking in again.

None of us are immune to fear, but I have learned over the years to take action even when I feel afraid. Every highly successful woman I know, including many of my guests on the podcast, talk about struggling with fear and doubt throughout their career, but they just don't let it stop them.

Don't interpret fear as a stop sign.

I love the saying "Feel the fear and do it anyway." There's a strength that comes from feeling afraid or having self-doubt, but not letting that stop you. When I work with coaching clients, I always encourage them to have greater faith in their abilities, to trust things will work out and to start with baby steps. Things won't always go exactly as planned, but you will get used to the feeling of being 'stretched' and over time and through that experience your comfort zone will grow.

4. Leverage the mind-body connection to your advantage

Having grown up in the world of competitive sport, I am hugely fascinated by the link between our mind, body and results. When we feel fear, we get a hit of adrenalin and cortisol, and our body thinks it's time for fight or flight. So, to work with fear in your career – when there are not any life-threatening challenges that you need to fight off or run from – you must focus on channeling that energy in a positive way or calming down your body and mind. Some practical strategies include:

- Breathe deep from your belly and exhale slowly. This will both calm down your nervous system and help you to focus.

- Avoid caffeine in coffee or tea prior to 'moments that matter' as it may increase your heart rate and can make some people anxious.

- Don't arrive rushed to a stressful situation like a big pitch or important meeting – arrive calm and collected. Ensure you have more than enough time to set up and get familiar with the environment.

- Use positive and strong body language to help you feel confident. If you ever see a performer backstage before stepping out in front of their audience, many will have a

ritual or routine that helps them get into the right state.

Our mind and body are intrinsically linked.

The tip on avoiding caffeine before presentations or pitches is especially helpful for those who tend to rush or talk fast when they are nervous. As someone who is naturally energetic and responds powerfully to coffee, I tend to avoid it before any speaking events. Despite my years of practice, I have found that being caffeine-free helps me stay balanced in my delivery and I find it much easier to communicate my thoughts. The key is to know yourself and choose the strategies that work for you. There is no one-size-fits-all approach.

5. Practice and repetition

Remember the first time you rode a bike, tried to swim or drove a car? Things are often scary when they are new and don't feel natural to us. Our subconscious mind is telling us to be careful, that we are heading into new territory and trying to keep us safe. Fear is a natural response to stretching your comfort zone, but once your mind gets used to the new experience, it starts to feel normal and becomes a muscle memory or automatic.

Repetition or practice is a great strategy to reduce fear and build your confidence and competence. When I first started speaking to big groups, I used to be really apprehensive as I didn't have much experience. As soon as I started doing more conferences and big

client events, my confidence and competence both went up. What could you start to practice this week to help reduce your fear? Remember – practice and repetition will help you tackle fear.

Coaching questions:

- What have you been putting off learning, doing or experiencing personally or professionally, because of fear of failure, or a fear of not being ready?
- What can you do this week or month to stretch your comfort zone?
- What would you do right now if you knew you absolutely couldn't fail?

Summary:

Many people interpret fear or doubt as a stop sign and put the brakes on, but the key is to learn to work with fear in your career or business. See fear as a sign you are growing and learning – it can be a good thing! If we stay in our comfort zone, we really are limiting our potential and it can lead to boredom or stagnation in our careers. I encourage all my clients who want to achieve more, have more, become more, to stretch themselves. I really encourage you to feel the fear, take a deep breath and do it anyway. See these situations (like the example of public speaking) as opportunities for growth and for unlocking more of your full potential. Remember that everything you deeply desire is just beyond your comfort zone, feel the fear and do it anyway. Jump!

KEY TAKEAWAYS:

1. Reprogram your mindset by changing your thoughts and beliefs.

2. Change your language.

3. Feel the fear and take action.

4. Leverage the mind-body connection.

5. Practice and repetition.

"Act as if what you do makes a difference. It does."

— William James

CHAPTER EIGHT

Impact, Influence and Visibility

"Personal impact is not easy to define, but we all know it when we see it. We meet someone and pretty soon we recognise they have a special quality. Call it magnetism, call it presence, call it charisma – call it what you like – but they stand out from the crowd."

— Vickers, Bavister and Smith

The ability to communicate with impact and influence in meetings, on calls, in job interviews, in client pitches or formal presentations is key to success. Some people even say that personal impact is the difference that makes the difference when it comes to achieving outstanding things in your career or business. It's something many clients come to me for

support with and it's something I have had to work on as a professional speaker and business owner.

Why does personal impact need to be in our "tool kit" for success? What are some of the specific benefits of boosting your impact and influence?

- To ensure your voice and ideas are heard and taken seriously
- To make a positive impression on clients and colleagues
- To be memorable in meetings, at job interviews, at events or online
- To boost your visibility and ensure you are not overlooked
- To increase your ability to engage, motivate, inspire and persuade

Like many of my clients, it took me a while to really appreciate just how important personal impact can be in the world of business. Unlike at school or university when our results were typically based on what we had learned, or facts we could recall - in the workplace our success also comes down to our ability to communicate our knowledge and expertise in a way that makes people want to listen and engage with us. Professional success is linked not just to intelligence, knowledge, and hard work, but also our personal impact, our visibility and ability to promote our work, our product or services, and our ideas.

So, how can we strengthen our personal impact, influence and visibility? How can we ensure our ideas

are heard and taken seriously? How can we make a great impression on clients and colleagues?

1. Remember the power of non-verbal communication

> *"Non-verbal communication is an elaborate secret code that is written nowhere, known by none and understood by all."*
>
> — Edward Sapir

We are always communicating, whether consciously or subconsciously and it's often our non-verbal signals that are overlooked. We are continually sending out messages to our clients and colleagues via our facial expressions and by the way we hold ourselves, sit, stand and move – both in person and virtually. Similarly, we are all 'reading' other people and forming impressions (often subconsciously) based on their body language and what we see visually, not just their words and tone of voice.

Some studies have shown that as much as 55% of the initial impact we make when we meet someone for the first time is from our body language, 38% from our tone of voice, while just 7% is from the words – what we actually said. Without getting bogged down in the exact percentages, I think we can all agree that non-verbal communication is an important part of making a good first impression and of personal impact in general.

Whether we like it or not, people are influenced by our body language, so self-awareness is key. Small things like making eye contact, standing up straight, facial expressions etc., can really impact how people perceive us and if they choose to work with us. However, there is a big difference between knowing this stuff, and actually doing it. So be especially mindful of your non-verbal communication during interviews, important meetings, or when delivering a presentation – when all eyes are on you, and you want to maxmise your impact and influence.

2. Tone of voice and delivery

When it comes to impact, it's not just what we say – but how we say it. Have you ever sensed that someone was angry, upset, enthusiastic, or bored through their tone? Have you ever heard someone say they were "fine," but you knew immediately they were not? Tone changes the meaning of our communication, and it can boost or minimise our impact and influence.

I vividly remember one of my psychology classes at university where I had the most amazing lecturer. She spoke in such an engaging and expressive way. She made us laugh, told stories and her passion for teaching shone through her tone of voice and her facial expressions. Students adored her and they loved coming to her class. To this day I think she played a big role in inspiring me to want to teach others and speak for a living. In contrast, I had another lecturer who spoke in a really slow and monotonous way. I used to look around

the lecture theatre and each week without fail, people would look bored, disengaged, and ready to doze off.

When communicating face to face, on phone calls or via web conference, we need to be aware of how we deliver our messages, how we engage our audience and our tone of voice – not just our content. Obviously everyone has their own natural style, and we don't have to go over the top, or act in a way that doesn't feel authentic or suit our personality, but small changes can make a big difference. If we want to boost our impact and be seen and heard, we may need to stretch our comfort zone and play a little bigger to ensure our delivery matches the environment and situation. For example, perhaps try modulating your tone of voice, turning up the dial just a little on your energy, or find other ways of engaging your audience through activities or questions.

3. Speak with confidence and conviction

Have you ever seen someone start a presentation with an apology? Or draw attention to a tiny mistake they made? Or point out their weaknesses? The interesting thing about this is that the audience is often completely unaware of the mistake or how nervous they are feeling, until the person points it out! We can be so hard on ourselves.

Without knowing it, we can undermine ourselves and minimise our impact, influence and credibility through small, seemingly insignificant things we say.

For example:

- I'm sorry that our director is unable to come today, you'll have to put up with me instead…
- Apologies if I'm nervous today, I don't often speak in public…
- I hope you don't mind, but...
- I am not an expert on this, but…

Whenever I mention this in my courses many people start to laugh and tell me they can relate. I know I have said many of these things in the past too! Sometimes people don't even realise they are speaking in a way that could be minimising their impact or credibility.

Research says that women tend to apologise a lot more than men in general, even when we have nothing to apologise for – almost out of habit. Do you say sorry a lot? Now this does not mean that we should never apologise, or that we can't say sorry – of course we can. Just be mindful of over-apologising. Often, we might start emails or conversations with "I'm sorry" without any valid reason to apologise. Many of my clients say this is something that they hadn't even realised they were doing, and once they became aware of it – and reduced it – they felt more confident and credible.

While we are talking about feeling apologetic, also remember that there is nothing wrong with being nervous in a potentially stressful or high-pressure situation. It's totally ok and you don't need

to apologise for it – like it's something to feel bad or embarrassed about. Other people probably haven't even noticed. We can often be our own worst critics!

4. Be humble or play big?

"There is no passion to be found in playing small – in settling for a life that is less than the one you are capable of living."

— Nelson Mandela

What do you do? The dreaded question…

Many smart, hardworking, and experienced women I meet have the tendency to play small and undersell themselves in their 'elevator pitch' and I used to do the exact same thing. When people used to ask me what I do for a living, I would say things like "I'm a trainer" or "I'm a coach," but I never shared more than that. I would never mention my years of experience as an inspirational speaker and coach, my qualifications, my client base, or my specific areas of expertise. I played so small and gave such a short response because I was scared that someone might think I was arrogant or judge me if I spoke "too highly" of myself. I hear this same fear from many of my female clients. Looking back, I also didn't value myself or my experience enough – just like many of the amazing women I meet. Can you relate?

Like many of my clients, I didn't realise that when people ask who you are and what you do, it's so much more than just giving a pre-planned speech – your "elevator pitch" or "value proposition." These are powerful moments when we can relate to someone and open up a conversation. Let people know who you are and share some insights into what you value or are passionate about. We might also share how we help our clients so they understand what we might be able to do for them.

Do you play small?

Often, we play small or talk about ourselves and our work in a way that doesn't really do us justice. As if anyone could do what we do and it's no big deal. I have heard so many brilliant women over the years do this. I remember a new coaching client about six years ago – in her first session I asked her about her work and her passions and interests. She told me she just managed "a small team" (which I later found out was in fact a global team of nine very senior people across several countries) and she also told me she was a keen runner. I said "Wow – that's amazing, I can't run to save my life" and she responded by saying... "Oh it's really no big deal, they're only half marathons!" She had a good laugh about this later as we unpacked her tendency to undersell herself and her achievements.

The thing is, when we undervalue our role or contribution, we often reflect this in our language, and talk like what we do is not that important. Furthermore, when we don't genuinely value ourselves, we may start

to convince others of the same. People will often mirror back to us how we feel or speak about ourselves.

How do you feel about selling yourself?

Do you assume people already know about your great work and your fabulous track record? When you look at people who have built strong brands and profiles, you will see that most of them don't play small when it comes to their elevator pitch, selling themselves or how they present themselves on their website or platforms like LinkedIn. They share information about their skill set, their experience and passions in a way that makes people want to know more.

Don't leave it to chance. It's your job to share with others who you are and how you may be able to help them. Consider who you are talking to and what they may be interested in knowing about you and adapt your response.

What do you say when people ask you what you do? Do you have a tendency to play small?

5. Are you a best kept secret?

"The power of visibility can never be underestimated."

— Margaret Cho

When it comes to your career and boosting your profile – you need to ensure people know about you and the great work you do. It can be easy to think our hard work will speak for itself – without any need to work on our profile or visibility. However, if you leave things to chance you may get overlooked – as out of sight often equals out of mind. It's also important to find a way that suits your natural preferences and works in your industry or sector.

How can you boost your visibility to ensure you don't miss out on opportunities?

There are lots of ways including:

- Speak up in meetings or on calls – share your opinion
- Use social media – post, comment and support others, engage in conversations and share helpful content
- Ask a question at events
- Use your camera intentionally on Zoom calls
- Build your network

It really depends on your career goals or business objectives, your personality, and who you want to be visible to. For example, some of my clients enjoy industry networking events or posting on LinkedIn, others don't, so I help them find another approach. It's important that you find a way that works for you.

Summary:

When it comes to impact and influence – consider your words, voice and body language. Both verbal and non-verbal behaviour. It's not just your knowledge and content (what you say) – but how you say it that influences and engages people. Believe in what you have to say – speak your truth and express your own opinion. Don't hold back out of fear of saying 'something silly.' Being seen and heard doesn't happen by accident: it takes effort and often involves stretching our comfort zone and playing a little bigger. What can you do to boost your personal impact? How can you ensure you are not a best kept secret?

KEY TAKEAWAYS:

1. Sharpen your body language – think about how you come across through your non-verbal communication.

2. Consider your tone of voice and the language you use.

3. Don't undervalue yourself. Be mindful of playing small.

4. Ensure you are not a best kept secret.

5. Believe in yourself!

"Believe in the magnetic power of your dreams."

— Anonymous

CHAPTER NINE

Career Changes, Leaps of Faith and the Power of Intuition

"We cannot become what we want to be by remaining where we are."

— Max De Pree

If you knew you couldn't fail – what would you do? How can you tell when it's time to leave a certain role or industry? Are you considering a change or pivot in your career?

Time for a change or leap of faith?

Career change is something I get asked about a lot by my clients and even more so since the global disruption and unprecedented change to our working lives associated with COVID-19. Some of my clients want to make small leaps internally, others want to initiate a complete sector or industry change. Increasingly, people seek me out as a coach to help them transition from corporate to starting their own business.

I have made a few big career changes myself in the past 20 years, such as leaving Australia to head to London for work, and taking a leap of faith to start my own coaching and consulting business full-time. However, the hardest decision I ever had to make was to hang up my dancing shoes and retire from ballroom dancing. It was a total 180 degree turn and everything felt upside down for a while as I worked my way out of Dancesport and into the world of psychology and performance coaching.

Should you stay or should you go?

I had danced six days a week for eight years of my life with my dance partner, and we had mapped out our futures as professional ballroom dancers. For years I had loved ballroom dancing and I enjoyed everything about it. The music, the self-expression and creativity of our routines, the travel, the dresses and the friendships. When all my friends went off to

university or started working, I chose to dance full-time. I couldn't imagine my life without dancing as that's all I knew. However, over the course of a year things started to change for me.

Looking back, the more successful we became at an international level, the less I started to enjoy it. I always loved the dancing, but not the intensely competitive side. I recall at one national championships my dancing shoes 'mysteriously vanished' from my bag right before the final round. Needless to say, the show had to go on that night – so I borrowed shoes from a fellow dancer that were a size too small and most notably didn't match my ballroom gown! So many stories from my dancing days…

Whereas many dancers prefer to specialise in one discipline, I was a 10-dancer, which meant in every competition I danced five Latin and five Ballroom routines. It was physically challenging and exhausting, and unlike the single discipline dancers, my partner and I hardly got any time to rest between heats when the focus shifts between Latin to Ballroom, and then back to Latin for the next round.

Ballroom to boardroom

By the time we were ranked sixth in the world 10-dance championships, the pressure had increased tenfold. The competitiveness and extreme perfectionism of the sport, alongside the financial pressures that dancing was putting on my family were consuming

me and leading to huge amounts of guilt and stress. Looking back, the physical impact of competing and training were also starting to show in my body (more about that later) and I knew in my heart that this was no longer the right path for me. I had to make a change.

It was without a doubt one of the hardest decisions I have ever had to make, and it took months to psych myself up enough to actually do it. I felt like I was letting so many people down. My dance partner, our families, our coaches and everyone who had supported us along the journey so far. What if I regretted this? What was I going to do now? I would literally have to start a new career from scratch. What did I want to do with my life now?

When you know it's time to leave

The day I decided to stop dancing was an extremely emotional day and one that I will never forget. It was like a moment in time when I literally changed tracks and headed in a completely different direction. There was no map of where I was even going and no guarantee it would work out. But I knew in my heart that it was the right choice for me for many personal, emotional and physical reasons and because of that, I have never regretted it. The ballroom dancing world had played its part in my life, but it was time for me to plot a new career path. The friendships and memories of my amazing journey will never leave me. I fondly recall those people who supported me and believed in

me, and I still draw on the experiences of Dancesport as they shaped who I am today.

Although career change can be scary, it can also be really exciting. Whilst it may be tempting to hold onto a role that is not working for us, the real career magic happens when we make a change, trust ourselves and take that step. It's often not as big a leap as it feels.

Times have changed

Times have changed and long gone are the days when people spent their entire careers at a single company. The average person will change career five to seven times during their working life according to career change statistics, and that figure is likely to rise in the future. Today, workers change jobs on average every 4.2 years, according to a report on employee tenure from the Bureau of Labour Statistics. With an ever-increasing number of career choices, 30% of the workforce will now change careers or jobs every 12 months. Furthermore, in the connected, digital world the barrier to entry for starting your own business, or 'side hustle' as some call it, has been significantly lowered. I know many people who have created portfolio careers where they do more than one thing and may have two or three different roles.

At the end of the day, it starts with you. Only you can tap into how you are feeling in your current role and industry, if you are feeling called to do something else or when it's time to make a change. Some changes

can be small, continuous improvements, whilst others are big career shifts. Only we know which working environments and situations bring out the best in us and help us thrive. Things are always changing and what once felt right for us might no longer be the right fit.

Coaching questions:

- What are you feeling called to stop, start or continue doing right now?
- Are you feeling called to make a change or shake things up? If so, what are you feeling called to do?

Career crossroads and embracing changes

"In the end we only regret the chances we didn't take."

— Oliver Goldsmith

A few years after I quit dancing, I found myself at another career crossroads. I had been working at a university for a number of years, as part of their business school's professional development program, and was also completing my postgraduate training to be a school psychologist. I was confused about what I wanted to do next in my career as there were a few different possibilities appearing before me. Should I start applying for jobs as a school psychologist? Would I stay working at the university as I loved delivering workshops for staff and students? Or perhaps I needed

to take that leap of faith and head overseas to the UK? I had Scottish ancestry so getting a UK work visa would be easy, and I had for some time felt a strong desire to move to London – as I really wanted to travel and work internationally.

Trusting your intuition

Eventually I decided to trust my intuition. So, I packed my bags and moved to London. I told myself that I was taking a year to travel and see the world, and then come back home and settle down. But deep in my heart I knew I was also chasing my private dream of being an inspirational speaker and coach. I wanted to create a career that allowed me to combine all my passions around psychology, professional development, teaching and coaching, helping people and travel. I was really scared and super excited, depending on the day of the week you asked me! But I knew for sure I was committed to taking the leap.

Leap and the net will appear

From the moment I landed in London in 2006, I felt like I got all the green lights. Within weeks I met two strangers in different contexts who, to this day, are still extremely close friends. It's where I started my own business and where I met my husband. It's where my career really took off and everything started to happen for me professionally. It really felt like it was meant to be.

When I look back at some of the best decisions I have made in my career, many, if not all of them, came down to following my intuition, taking leaps of faith and trusting things would work out. There was typically no 'logical reason' why I felt called to do a particular thing and no proof or guarantee that things would work out. In every situation I just felt a strong intuitive feeling that I should do something.

Conversely, when I haven't listened to my inner knowing or followed my gut in a personal or professional situation, I have usually regretted it. Have you ever had an experience where you knew something wasn't right for you, but you didn't listen? Perhaps got swayed by someone else's opinion, went against what you felt to be true in your heart and later regretted it? I have, and so have most of my clients at some point.

Intuition can be a huge strength for many women in their careers and in the world of business – if we learn to listen to it! So many amazing women I have had the pleasure of working with over the years or interviewed on *The Psychology of Successful Women Podcast* – all talk about the importance of trusting our intuition. The more we learn to tap into our intuition the more we hear it.

Summary:

"The more you trust your intuition the more empowered you become, the stronger you become and the happier you become."

— Gisele Bundchen

At the end of the day, only you know what is right for you – so follow your own internal guidance system when it comes to making career choices. You need to develop a deep sense of faith and self-trust, because when we don't listen – we often regret it! I know in my own life, I only feel bad when I don't listen to my intuitive feelings as they are usually right. As you learn to trust yourself your confidence will grow. It's about tapping into what feels right and true for us.

Are you trusting yourself and listening to your intuition in your career?

KEY TAKEAWAYS:

1. Times have changed – most people will go through several career changes during their working life.

2. Be open to new opportunities that present themselves in your career. What once felt right for us might no longer be the right fit.

3. Learn to create space and quiet time to really listen to your intuition.

4. Trust yourself when it comes to your big career decisions – only you know what's right for you and what will make you deeply happy and fulfilled.

"Everything is figureoutable."

— Marie Forleo

Bouncing Back from Setbacks

"More than education, more than experience, more than training, a person's level of resilience will determine who succeeds and who fails."

— Harvard Business Review

Have you ever had one of those moments in life where you know things are never going to be the same again?

One morning, a few months after I stopped ballroom dancing, I woke up in considerable pain. For some unknown reason, many of my joints were extremely swollen and I couldn't close my hands to make a fist. Confused and concerned, I went to a range of different doctors and had various tests and X-rays to try and determine what was happening. Was I having

an allergic reaction to something? Had I been bitten by something? Had I caught some form of virus when I had been dancing overseas? Nobody could work out what was causing my pain and inflammation and things kept getting worse.

My biggest lesson in resilience

A few weeks later, I found myself sitting in a deadly quiet waiting room in West Perth. I remember looking around and realising I was the only young person there and everyone else looked about the age of my grandma. The doctor eventually called me into his room and the look on his face warned me that it was not good news. He said: "Shona – I'm really sorry to have to tell you this, but your tests have all come back positive for Rheumatoid Arthritis."

At the time, I didn't really know what that meant. I'd heard the name before, but I thought that arthritis was something that older people got as their joints start to wear and deteriorate with age. He told me there was another form of arthritis called Rheumatoid Arthritis which you can get earlier in life and it's much more common in women than men. It's an auto-immune disease where your immune system doesn't work correctly, and rather than protecting you and warding off infections, your body starts attacking itself. He went on to say that it was incurable and that I would probably need to be on strong medication to control it for the rest of my life.

I was in total shock. There was no family history of this. How did I get it? Was it to do with pushing my body so hard physically through all those years of dancing? Was this in some way my fault? Sadness and confusion started to kick in. What did this even mean?

He proceeded to explain that he would put me on medication immediately to try and control the inflammation and get me out of pain. I would also need a course of steroid injections. The problem with Rheumatoid Arthritis is that the longer your joints are inflamed the more chance you have of long-term damage which can lead to joint replacements and sometimes even disability. The younger you are diagnosed – the higher your risk of long-term complications. Unfortunately for me, that has since meant several major surgeries and three joint replacements.

If you've ever had a family member touched by Rheumatoid or another auto-immune illness, you might know there's a drug called Methotrexate. It's actually a form of chemotherapy medication used to treat cancer. It's highly toxic and it even comes with a warning that says: "*Methotrexate may cause very serious, life-threatening side effects. You should only take methotrexate to treat cancer or certain other conditions that are very severe and cannot be treated with other medications. Talk to your doctor about the risks of taking methrorexate for your condition.*"

Thankfully the methotrexate days are long behind me now, and it would take another book to explain the

ups and downs of living with Rheumatoid Arthritis over the years. However, I am a big believer in "what doesn't kill you makes you stronger" and I am sure many of you reading this book have had to face your own personal battles. Importantly, it hasn't stopped me from building a career and business I love, and my experiences have taught me so much about resilience, the power of a positive mindset, and the importance of self-care, all of which I now enjoy helping my clients apply to their own circumstances.

Whether it's embracing change, dealing with setbacks in your career or business, negative feedback, a lost opportunity or a communication breakdown, we all need strategies to help us bounce back from challenges if we want to achieve success and happiness.

"Life doesn't get easier or more forgiving. We get stronger and more resilient."

— Steve Maraboli

What is resilience?

Resilience is defined by the American Psychological Association as: *"The process of adapting well in the face of adversity, trauma, tragedy, threats or significant sources of stress – such as family and relationship problems, serious health problems or workplace and financial stressors."*

People with high levels of resilience think and act in ways that help them cope with change and setbacks.

For example, they are flexible and can adapt to changing situations. They also tend to be positive and hopeful – believing the future can or will be better – even if they are in the middle of a challenge. Highly resilient people also don't tend to dwell on setbacks and things they can't change.

In the modern workplace and global economy, resilience has become an increasingly important part of our tool kit for success. The COVID-19 pandemic has highlighted just how much we need it in both our personal and professional lives! The great news is – we can all strengthen our resilience by adapting our mindset and behaviour.

How can we strengthen our resilience? What tools and techniques can we use to bounce back from setbacks and adversity in our career? What can we do when the going gets tough?

Practical strategies to boost resilience

1. Building strong relationships inside and outside the workplace

Building strong and supportive relationships has been shown to be a powerful 'protective factor' in terms of helping us bounce back. People who are good at reaching out to others, talking about their challenges or setbacks, asking for help and then accepting that help, tend to cope better.

Conversely, people who try to cope with everything on their own, don't reach out to others, or perhaps don't have the support networks in place, often display lower levels of resilience. As leaders, managers and colleagues – it can be important to be on the lookout for people who may not have the supportive relationships or network they might need.

Who do you reach out to when things don't go to plan? How are you at asking for and accepting help?

2. Control the controllable

In terms of building resilience – a powerful strategy is to learn to focus your attention on your sphere of influence and the things you can control.

All the successful women and peak performers I've had the chance to work with and speak to over the years – including Olympic medallists, talk about training themselves to 'control the controllable', as that is where their power is. It's a great strategy for resilience, but it's also a powerful strategy for success and high performance in general.

Conversely, when you focus too much of your attention and energy on the things you can't control or change, it leads to stress, can increase your anxiety, impact your motivation, reduce your self-confidence and ultimately lead to poor performance. Create the habit of focusing most of your attention and energy on the things you can control in your career or business.

As a professional speaker, I used to spend a lot of my time worrying about things that were beyond my control. What happens if something goes wrong with the set-up or technology? What happens if some of the people are having a bad day when they come to my session? What happens if some people don't warm to me? What happens if…? I'd ask myself a lot of these questions, which were focusing my attention on the things I couldn't control rather than the things I could.

Over the years I have learned to focus on things I can influence and control such as the session scope, my preparation, my mindset, energy and body language. I always do an IT run through before virtual events too.

Coaching questions:

- What can you control in your career or business?
- What can't you control?

We might not be able to control what the market does, what our competitors do, what happens with technology or a global pandemic. However, we can control our own behaviour and mindset, how we choose to respond to events, how we communicate with others, the feedback we seek and our own development etc. There are lots of things in our sphere of influence if we go looking. When it comes to resilience at work – we must 'control the controllable.'

3. Take things one step at a time

A powerful strategy for resilience and avoiding being overwhelmed is to not look too far ahead. A lot of my clients over the years have been through significant personal and professional challenges like organisational restructures, family and health challenges, burnout or redundancy. Instead of thinking too far ahead, it can be really helpful to take things step by step, day to day.

When I went through my joint replacement surgeries, I recall my mind racing ahead and starting to worry about what the final outcome would be. The most recent operation involved a bone graft from my hip to support a 'reverse' shoulder replacement. As a result, I couldn't walk properly or use one arm for several months. Nobody, not even my brilliant surgeon, knew how successful the operation might be, or more worryingly, how much movement I would lose in my arm as I'd already had the shoulder replaced once, just four years prior.

We had to wait several months and hope for the best. To avoid totally freaking out during the long and slow rehab process, I found it incredibly helpful to take things step by step. I consciously tried to not look too far ahead into the future with all the many unknowns. I use this same strategy to deal with change and setbacks as a business owner.

Ask yourself, what is something you can do in the next hour or the next day to help you deal with a current

challenge? What are some small baby steps you can take to help you get through the next 24 hours? Importantly, when we just focus on small steps, it's less overwhelming and things usually do change, get better, or at least become easier to deal with over time.

4. Self-care

> *"We also have to focus on ourselves, because at the end of the day, we're human, too. So, we have to protect our mind and our body, rather than just go out there and do what the world wants us to do."*

— Simone Biles

There is a powerful link between self-care and resilience. Our physical health is connected to our emotional and mental health. When we have a healthy lifestyle, we tend to feel better. When we take care of ourselves and refill our own cup, we cope better with stress and challenges. Self-care practices like engaging in exercise, mindfulness or meditation, rest and eating well, all feed into a positive cycle of resilience. They help us bounce back.

Remember the airplane emergency analogy that if we don't look after ourselves first and put on our own oxygen mask, there really isn't any way we can help others. Unfortunately, self-care is often the first thing that falls off the list of priorities when you need it most.

Many of the women I work with are so hardworking and good at supporting other people, that self-care is sometimes seen as a luxury rather than a fundamental ingredient in creating and sustaining a thriving career.

How are you with self-care? What is your go-to list of activities to refuel and replenish? I love walking my dog, going to the beach, being in nature, listening to inspirational music (see the PSW playlist in the book bonuses!), reading and journaling. I typically need alone time to refuel. What helps you bounce back and refill your cup? What is in your self-care tool kit? Like many things, it's about knowing yourself, what you need and what suits your lifestyle.

Summary:

Resilience is the ability to bounce back from setbacks, and challenges in our personal and professional lives. Boost your resilience by being flexible and adaptable, developing a resilient mindset and avoid focusing on the things you cannot change or control. Take care of yourself physically and emotionally, build strong relationships and reach out to others for help and support. Remember, we can't predict the future, but building resilience will be key to your success and happiness.

KEY TAKEAWAYS:

1. Build strong relationships and reach out to others for help and support. Relationships and support systems are key to resilience.

2. Focus on the things you can control and influence, not the things you can't. Remember to 'control the controllable.'

3. Try not to look too far ahead as it can sometime be overwhelming – focus on taking things one step at a time. Think small steps.

4. Self-care is key to resilience – we must refuel and look after ourselves if we want to bounce back from setbacks and have a fulfilling and sustainable career.

"Success comes from having dreams that are bigger than you fears."

— Bobby Unser

Final Secrets to Supercharge Your Success

*"You are the designer of your destiny;
you are the author of your story."*

— Lisa Nichols

The previous chapters have unpacked ten of the most common themes, topics and challenges that have come up with my female clients over almost two decades. In this chapter I wanted to leave you with four final guiding principles that can supercharge your success and ensure you enjoy the journey as much as the destination.

1. Take charge of your success and be the best you can be

A common characteristic of all the happy and successful women I have had the pleasure of knowing and working with over the years, is the desire to keep learning, improving and upskilling to be the very best they can be. They are proactive about their own development, passionate about their progress and take charge of their success. Let's face it – nobody will ever care as much about our career or business as we do, so it's up to us to make things happen.

Most high performers in any field, from sports to business, are continuously trying to 'sharpen the saw' and hone their craft. They are always looking to raise the bar on their own mindset, behaviour and performance.

"Success is something you attract by the person you become."

— Jim Rohn

How do you like to learn? How do you ensure you keep developing and growing? Do you prefer small group programs, online courses, webinars or live events? Maybe a combination of all of them. These days there are so many options, but we must take charge of our own growth and success and not leave things to chance. One of the most important things we can do is to keep building our skill set and sharpening our mindset to ensure we stay at the top of our game.

When we are continually learning and growing, and setting new goals, we also stay inspired and motivated.

Remember – *the single most important factor in your career or business success is you!*

To help you on this journey, I encourage you to access a bunch of practical resources that come for free with this book. Go to www.shonarowan.com/pswbonuses to download the associated book resources.

2. Don't let a fear of judgement hold you back

"To avoid criticism, say nothing, do nothing, be nothing."

— Aristotle

What will people think? What if some people don't like me?

One of the most common concerns I hear from my female clients is a deep fear of being judged or criticised by others. This fear pops up in many different situations including when they want to play a bigger game, speak in public, say no, boost their visibility, do something different or unique, or engage in any form of self-promotion.

"Be you so that the people looking for you can find you."

— Mel Robbins

The desire to be liked and accepted are part of being human, but as author Rebecca Campbell says, **"You are not for everyone"** and I always remind my clients and myself of this. It's impossible for everyone to like us or understand us, and that is ok. We all value different things and have our own likes and preferences. However, if you let a fear of being judged or criticised hold you back, the people that do like and appreciate you, and need what you have to offer in your unique way, will miss out. Focus instead on your supporters more than the potential critics. Think about the contribution you want to make, the people you want to help and on being the best you can be.

3. Seek help and support

"If you want to go quickly, go alone. If you want to go far, go together."

— African proverb

If you want to fast track your career or business – seek help and support. Find someone who can help you get there faster and easier than you could on your own. When I decided to start my own business, there was a lot I had to learn. And fast! Yes, I knew the world of peak performance and professional development as I had been in that arena a long time, but I needed help with many areas like overcoming my own self-doubt and fears, building my brand and profile, networking and business development. I needed support, guidance and practical advice. So,

I joined programs and sought out coaches who had the experience and skills I needed. I didn't try to work it all out on my own.

Whatever your career or business goals are – don't try and work it all out on your own. It can be way harder, more stressful and take much longer on the solo route. Also – remember that knowing something in theory or at a logical level, is not the same as actually doing it. It takes practice to create real, sustainable change in our mindset, behaviour or skill set. That is why both my career and business acceleration programs are spaced over several months – to provide my clients with the time and support to apply the learnings, create new habits and achieve their goals.

Engage someone who can guide you, help you uncover your blind spots, give you the short cuts and champion you along the way. Choose a person you really gel with who knows their stuff and understands your specific challenges and goals. Someone who can help you break through any subconscious or self-imposed barriers about what is possible for you. We all need people who support, inspire and challenge us, and we achieve more when we have someone in our corner, checking in and cheering us on. We can't do it alone and we are not supposed to.

What support or coaching could help you right now in your career or business?

4. Enjoy the journey

*"If you obey all the rules,
you miss all the fun."*

— Katherine Hepburn

When it comes to success and achieving our goals, we must remember to enjoy the journey and celebrate our wins along the way. Remind yourself to have fun, be present and 'smell the roses'. Allow yourself time to reflect and feel proud of what you have already achieved in your career or business.

When I look back at my career as a ballroom dancer and in my early years as a business owner, I really didn't enjoy the journey anywhere near as much as I could have. I used to put a lot of pressure on myself, felt quite isolated and was not good at reaching out for help. I also used to do things I didn't really want to do and stay in situations that I knew were not right for me. Nowadays, creating an enjoyable and fulfilling career that aligns with my core values is really important to me, and many of my clients say the same.

So remember, it's not just about the destination, it's about who you become, what you learn, the fun you have, the impact you make and the amazing people you meet along the way!

KEY TAKEAWAYS:

1. Take charge of your success, keep learning and growing to be the best you can be.

2. Don't let a fear of being judged or criticised hold you back or stop you from chasing your dreams.

3. Seek help and support to achieve your goals. We can't do it alone, and we're not supposed to.

4. Enjoy the journey and celebrate your wins along the way.

"You are the secret to your success."

— Shona Rowan

Next Steps and Free Resources

The journey continues

It's been a huge pleasure to connect with you on these pages and the good news is – this isn't the end. There are lots of ways I can support you at an individual or organisational level going forward.

Firstly, you can download the free book bonuses and resources I have created for you at: **www.shonarowan.com/pswbonuses**.

This includes a bunch of practical resources and a Spotify playlist to keep you feeling inspired and positive!

If you would like to go deeper and work with me live, you can find out more about the *The Psychology of Successful Women* – **Career Acceleration Program** on the following page or view the course page here: www.psychologyofsuccessfulwomen.com/program/

If you work for a company or own your own business and would like to engage me, please keep reading for ways I can support you and your people.

Stay in touch

If you would like to connect and find out more about my work, go to:

- www.shonarowan.com
- www.psychologyofsuccessfulwomen.com
- https://au.linkedin.com/in/shonarowan
- www.instagram.com/shonascouch/
- support@shonarowan.com

Please tag me in any book pictures too. It will make my day to see who has been reading the book and I will share them on my social media channels.

I look forward to the possibility of connecting with you again soon.

To your success and happiness!

Shona

www.shonarowan.com

www.psychologyofsuccessfulwomen.com

P.S. Don't forget to sign up for my free Succeed and Thrive monthly E-zine at www.shonarowan.com

Career Acceleration Program

This highly practical, step-by-step and results-focused coaching program is specifically designed to help women take charge of their careers, maximise their results and claim the success they deeply desire.

What's included?

- Live masterclasses and coaching calls with Shona
- Live webinars with Shona
- Exclusive online course learning portal: videos, practical content, resources and templates
- A supportive community of inspirational women to mastermind and network with
- Personal support and tailoring to achieve your specific goals
- Limited group size to maximise results

www.psychologyofsuccessfulwomen.com/program/

The **Career Acceleration Program** is delivered in two ways:

As an open program: Delivered live via Zoom and supported by an exclusive online learning portal. Women attend from all over the world. Join the waitlist and find out more here: www.psychologyofsuccessfulwomen. com/program/

In-house: Many organisations engage Shona to deliver the **Career Acceleration Program** to a specific cohort of their women as part of their professional development and leadership training. See www. shonarowan.com

Email support@shonarowan.com to set up a free consultation.

Keynote Events and Workshops

Inspire, Develop and Retain your People and Clients

www.shonarowan.com

Shona is well known for her highly practical and inspirational keynotes and workshops. She doesn't believe in a one-size-fits-all approach, so she works with her clients to design and build a session that is tailor-made for their specific needs.

As a professional speaker with almost two decades of international experience, you can rest assured that Shona will deliver a session that inspires and engages your audience. See www.shonarowan.com for client testimonials or to get in touch.

Some popular topics include…

- The Psychology of Successful Women
- Imposter Syndrome, People Pleasing and Perfectionism
- Ballroom to Boardroom
- Thrive: Practical Strategies for High-Performance and Well-Being
- Stand Out from the Crowd and Accelerate Your Success

- Leading and Managing High-Performing Teams
- Communicating with Clarity, Confidence and Credibility

Entrepreneur and Business Owner Program

This coaching and mentoring program is specifically designed to help female business owners and entrepreneurs to boost their performance, sharpen their mind-set and achieve their business goals.

This program is by application only and is tailored to your needs as a business owner. It includes live coaching with Shona, a dedicated online portal of practical resources and access to a supportive community of like-minded women in business.

Please contact us to find out more:

www.psychologyofsuccessfulwomen.com

support@shonarowan.com

Free Resources

1. **Free Training:** 5 Practical Success Strategies for High-Achieving Women.

2. **Shona's monthly E-zine:** Packed with practical tools, techniques, downloads, videos and resources to help you boost your success.

Go to www.shonarowan.com

To access other resources and downloads for free, go to:

www.psychologyofsuccessfulwomen.com

The Psychology of Successful Women Podcast

with Shona Rowan

The Psychology of Successful Women Podcast is an inspirational show that helps women maximise their performance from the inside-out and thrive in the world of business.

The Psychology of Successful Women

Shona Rowan and her trailblazing guests talk about how they have built a successful career or thriving business, and how they cope with setbacks and challenges. Most importantly, each episode will help you sharpen your mindset, share practical advice and inspire you to take your success to the next level.

www.psychologyofsuccessfulwomen.com/podcast

The podcast is also available on all major podcasting platforms.

Notes

Notes

Lightning Source UK Ltd.
Milton Keynes UK
UKHW020642140622
404409UK00010B/833